Cool Restaurants
Mallorca/Ibiza

teNeues

Imprint

Editor: Eva Raventós

Introduction: Cristian Campos

Research: Maia Francisco

Photography: Roger Casas

Layout & Pre-press: Oriol Serra Juncosa

Translations: Heather Bagott (English), Susanne Engler (German),
Marion Westerhoff (French), Maurizio Siliato (Italian)

Produced by Loft Publications
www.loftpublications.com

Published by teNeues Publishing Group

teNeues Book Division
Kaistraße 18
40221 Düsseldorf, Germany
Tel.: 0049-(0)211-994597-0
Fax: 0049-(0)211-994597-40
E-mail: books@teneues.de

teNeues Publishing Company
16 West 22nd Street
New York, NY 10010, USA
Tel.: 001-212-627-9090
Fax: 001-212-627-9511

teNeues Publishing UK Ltd.
P.O. Box 402
West Byfleet, KT14 7ZF
Great Britain
Tel.: 0044-1932-403509
Fax: 0044-1932-403514

teNeues France S.A.R.L.
4, rue de Valence
75005 Paris, France
Tel.: 0033-1-55766205
Fax: 0033-1-55766419

teNeues Ibérica S.L.
c/ Velázquez, 57 6.º izda.
28001 Madrid, Spain
Tel.: 0034-657-132133

teNeues
Representative Office Italy
Via San Vittore 36/1
20123 Milano, Italy
Tel.: 0039-(0)347-7640551

Press department: arehn@teneues.de
Phone: 0049-2152-916-202

www.teneues.com

ISBN-10: 3-8327-9113-2
ISBN-13: 978-3-8327-9113-1

Bibliographic information published by Die Deutsche Bibliothek.
Die Deutsche Bibliothek lists this publication in the Deutsche Nationalbibliografie;
detailed bibliographic data is available in the Internet at http://dnb.ddb.de.

Contents

Page

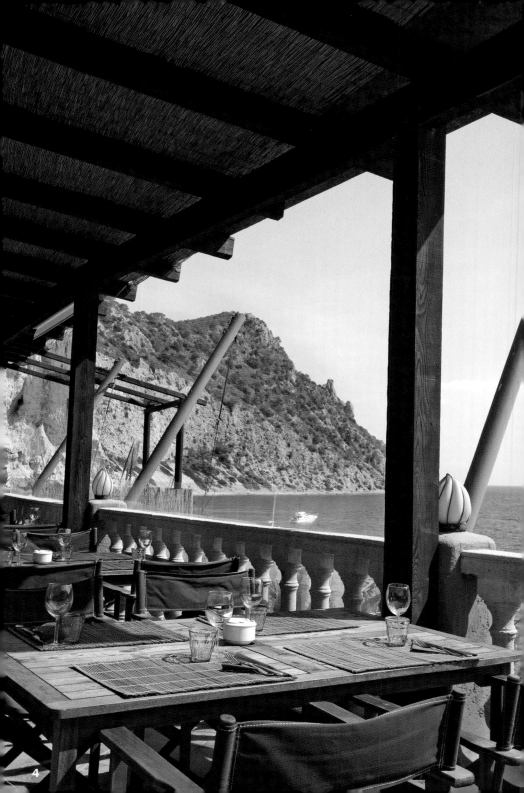

Introducción

Tradición y modernidad se unen sin complejos en el panorama gastronómico de dos de las islas con más encanto del mar Mediterráneo, Mallorca e Ibiza, consideradas actualmente, junto con Cataluña (con la que comparten algo más que el idioma), bastiones de la alta cocina moderna. La cocina tradicional de las islas Baleares, basada en las actividades pesquera y agrícola típicas de la zona, ha dado lugar a lo largo de su historia a recetas y productos autóctonos como la ensaimada (un bollo dulce cuyo nombre proviene de la manteca de cerdo, "saïm"), la sobrasada y el "camaiot" (embutidos de acentuada personalidad), los licores típicos de Ibiza, la mítica caldereta de langosta, el "xotet" (un plato elaborado con cordero), el "trempó" (ensalada de tomate, cebolla y alcaparra), el "arròs brut" (arroz con verduras, pichón y liebre) o el "frit" mallorquín (asadura y sangre de cerdo con patata y cebolla).

Junto con la cocina tradicional han florecido recientemente decenas de restaurantes regentados por chefs que han explorado las últimas tendencias culinarias sin dejar de lado las raíces de una gastronomía de gran riqueza y variedad. Este libro no es tanto un simple catálogo de restaurantes señeros de este rincón del Mediterráneo como un recorrido guiado por algunos de los templos culinarios baleáricos y sus recetas estrella.

Sólo en la isla de Mallorca podemos encontrar más de mil doscientos restaurantes, de los que un pequeño porcentaje se conocen como "cellers", considerados los santuarios de la cocina mallorquina. Se trata de auténticas bodegas donde se pueden degustar platos típicos de las islas elaborados según recetas que en algunos casos se remontan a los años de la conquista romana, alrededor del 123 a. de C. La mayoría de las bodegas se encuentran en la ciudad de Inca, pero también pueden hallarse en prácticamente todas las poblaciones de Mallorca e Ibiza. Los restaurantes de este libro son, en muchos aspectos, herederos de esa tradición, los "cellers" de nuestros días: modernos depositarios de una gastronomía que ha perdurado a lo largo de los siglos y que ahora vive una edad de oro gracias a la popularización del diseño, entendido éste tanto en su vertiente arquitectónica como en la culinaria.

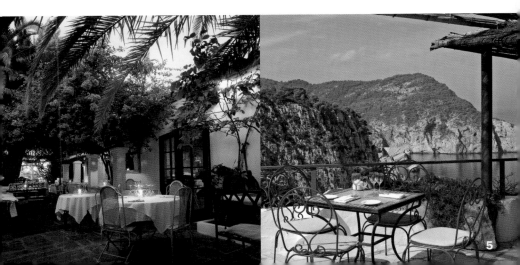

Introduction

Tradition meets modernity in the gastronomy panorama of Majorca and Ibiza, two of the most charming Mediterranean islands. Together with Catalonia (sharing more than just the language), the islands are considered bastions of modern day "haute cuisine". The traditional cuisine of the Balearic Islands, based on the fishing and farming activities typical of this region, has provided recipes and indigenous products through the passage of time, such as the "ensaimada" (a type of sweet pastry whose name originates from the word for lard, "saïm"), "sobrasada" (spicy sausage paté) and "camaiot" (unique sausages), typical Ibizan liqueurs, the renowned "caldereta de langosta" (lobster broth), "xotet" (a lamb dish), "trempó" (tomato, onion and caper salad), "arròs brut" (rice dish with hare, pigeon and vegetables) or the Majorcan "frit" (a favourite made with pork oinnards and blood, potato and onion).

In addition to traditional cuisine, a great number of restaurants have recently flourished which are run by chefs who have delved deeply into the latest culinary trends without ignoring the origins of this extremely rich and varied gastronomy. More than just a catalogue of good restaurants in this corner of the Mediterranean, this book is a guided tour of some of the Balearic culinary temples and their best recipes. Majorca alone is home to more than 1200 restaurants, a small part of which are known as "cellers", considered sanctuaries of Majorcan cuisine. These authentic wine cellars offer a place in which to taste typical local dishes based on some recipes that date back to roman times, around 123 BC. Most of them are located in the town of Inca, but can be found all over Majorca and Ibiza. The restaurants in this book are, in many aspects, inheritors of this tradition. The "cellers" today are modern depositories of a gastronomy which has endured over centuries, and thanks to the popularisation of design in both architectural and culinary terms, it is currently enjoying a golden age.

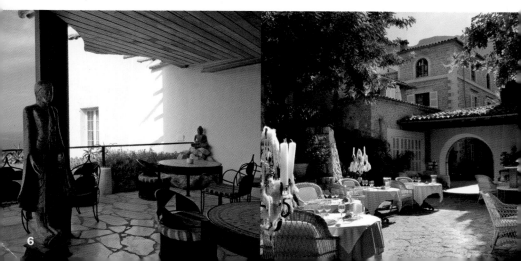

Einleitung

Tradition und Moderne vereinen sich problemlos in der gastronomischen Landschaft der bezaubernden Mittelmeerinseln Mallorca und Ibiza. Man betrachtet die Inseln heutzutage zusammen mit Katalonien, mit dem sie mehr gemeinsam haben als nur die Sprache, als die Hochburgen der modernen Haute Cuisine. Die traditionelle Küche der Balearen basiert auf typischen Produkten aus dem Fischfang und der Landwirtschaft dieser Region. Es entstanden im Laufe der Zeit einheimische Rezepte und Erzeugnisse wie die „Ensaimada" (ein süßes Gebäck, dessen Name sich von Schweineschmalz „saïm" ableitet), „Sobrasada" (würziger Wurstaufstrich) und „Camaiot" (einzigartige Wurst), die typischen Liköre von Ibiza, die fast mythische „Caldereta de langosta" (Langustenbrühe), „Xotet" (Lammgericht), „Trempó" (Tomaten-, Zwiebel- und Kapernsalat), „Arròs brut" (Reisgericht mit Hasenfleisch, Taube und Gemüse) oder mallorquinisches „Frit" (Gericht aus Innereien und Blut vom Schwein, Kartoffeln und Zwiebeln).
Neben den traditionellen Lokalen wurden in den letzten Jahrzehnten zahlreiche Restaurants eröffnet, in denen Chefköche neue kulinarische Trends umsetzen, ohne dabei die reichen, vielseitigen und unverfälschten Wurzeln der einheimischen Küche zu vernachlässigen. Dieses Buch ist nicht einfach ein Katalog der bedeutendsten Restaurants in diesem Teil des Mittelmeers, sondern eine Führung durch einige der kulinarischen Tempel der Balearen mit ihren besten Rezepten.
Allein auf Mallorca gibt es mehr als 1.200 Restaurants. Einen kleinen Prozentsatz davon machen die sogenannten „cellers" aus, die Heiligtümer der mallorquinischen Küche. Die Cellers sind echte Bodegas, die die typischen Inselgerichte zubereiten, manchmal nach Rezepten, die auf die Zeit der römischen Eroberung um 123 v. Chr. zurückgehen. Die meisten Bodegas gibt es in Inca, aber sie sind auch in fast allen anderen Dörfern Mallorcas und Ibizas zu finden. Die Restaurants, die wir vorstellen, sind die Erben der Tradition, die „Cellers" der heutigen Zeit, moderne Bewahrer einer Gastronomie, die Jahrhunderte überlebt hat und jetzt ihr goldenes Zeitalter erlebt, ein Zeitalter, in dem das Design sowohl in der Architektur als auch in der Gastronomie an Bedeutung gewinnt.

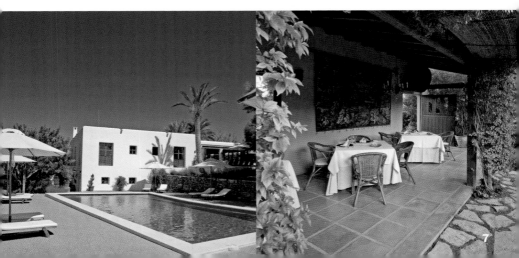

Introduction

Tradition et modernité se mêlent sans complexes dans le panorama gastronomique de deux des îles les plus enchanteresses de la mer Méditerranée, Majorque et Ibiza, considérées aujourd'hui, avec la Catalogne (dont elles partagent plus que le langage), bastions de la haute cuisine moderne. La cuisine traditionnelle des îles Baléares, basée sur les activités de pêche et de cultures typiques de la zone, a élaboré, au fil de son histoire, des recettes et des produits locaux, à l'instar de la « ensaimada » (une sorte de gâteau dont le nom vient du saindoux, « saïm »), la « sobrasada » (pâté très relevé) et le « camaiot » (saucisson unique en son genre), les liqueurs typiques d'Ibiza, la mythique « caldereta de langosta » (soupe de langouste), le « xotet » (plat à base de viande d'agneau), le « trempó » (salade de tomates, oignons et câpres), l' « arròs brut » (plat à base de riz, pigeon, lièvre et légumes) ou le « frit » majorquin (un classique à base d'abats de porc, sang, pommes de terre et oignons).

A côté de la cuisine traditionnelle, un grand nombre de restaurants se sont multipliés au cours de ces dernières décennies, dirigés par des chefs qui ont exploré et approfondi les dernières tendances culinaires sans laisser de côté les racines d'une gastronomie très riche, diversifiée et authentique. Ce livre n'est pas un simple catalogue de restaurant phares de ce coin de la Méditerranée. Il nous guide aussi au cœur de certains des temples culinaires des Baléares, nous dévoilant leurs plus célèbres recettes.

Seule l'île de Majorque comporte plus de 1.200 restaurants. Un petit pourcentage d'entre-eux sont les dénommés « cellers », considérés comme les sanctuaires de la cuisine majorquine. Caves authentiques, on peut y déguster les plats typiques des îles élaborés selon des recettes qui, pour certaines, remontent aux années de la conquête romaine, autour de 123 av. J.-C. La majorité des caves se trouve dans la ville d'Inca, mais il y en a dans tous les villages de Majorque et d'Ibiza. Les restaurants de ce livre sont, à bien des titres, les « cellers », de nos jours, fiers héritiers ce cette tradition. Dépositaires contemporains d'une gastronomie qui a survécu des siècles durant et qui, aujourd'hui connaît un âge d'or grâce à la vulgarisation du design tant sur le plan architectural que sur le plan culinaire.

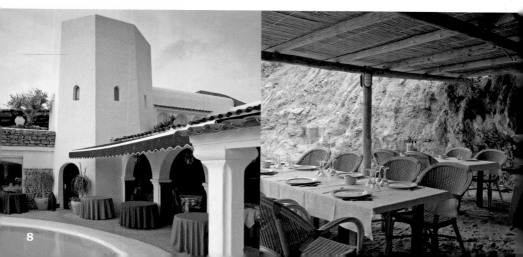

Introduzione

Tradizione e modernità si fondono senza complessi nel panorama gastronomico di due delle più affascinanti isole del mar Mediterraneo, Maiorca e Ibiza, considerate attualmente, assieme alla Catalogna (con cui hanno in comune molto di più della lingua), esponenti di rilievo dell'alta cucina moderna. Nel corso del tempo la cucina tradizionale delle Isole Baleari, basata principalmente sui prodotti agricoli ed ittici, ha dato luogo a ricette e prodotti autoctoni. Tra questi, l'"ensaimada" (una sorta di brioche dolce il cui nome proviene dallo strutto di maiale, "saïm"), la soppressata e il "camaiot", (insaccati con una forte personalità), i liquori tipici di Ibiza, la mitica zuppa di aragosta, ed ancora, altri piatti altrettanto rinomati quali il "xotet" (un piatto di agnello), il "trempó" (insalata di pomodori, cipolla e capperi), l'"arròs brut" (riso con lepre, piccione e verdure) o il "frit" maiorchino (frattaglie e sangue di maiale con patate e cipolle).

Recentemente, assieme alla cucina tradizionale sono sorti numerosi ristoranti gestiti da chef che, senza abbandonare le radici di una gastronomia ricca e variata, esplorarano le ultime tendenze culinarie. Questo libro non è soltanto un semplice catalogo di rinomati ristoranti di quest'angolo del Mediterraneo, bensì un percorso guidato all'interno di alcuni tra i più singolari templi culinari delle Baleari, e dei loro piatti più famosi.

Soltanto nell'isola di Maiorca si possono trovare più di 1.200 ristoranti. Una piccola percentuale di questi vengono chiamati "cellers", e sono considerati dei veri e propri santuari della cucina maiorchina. Si tratta di autentiche cantine dove è possibile degustare vari piatti tipici delle isole, elaborati seguendo ricette antichissime, che in alcuni casi risalgono addirittura alla conquista romana, all'incirca al 123 a.C. La maggior parte di questi "cellers" si trova nella cittadina di Inca, anche se è possibile trovarne praticamente in tutte le principali località di Maiorca ed Ibiza. I ristoranti di questo libro sono, per molti aspetti, gli eredi di questa tradizione, i "cellers" dei giorni nostri: moderni depositari di una gastronomia che è sopravvissuta nel corso dei secoli e che adesso attraversa un periodo di splendore grazie alla crescente popolarità di un design non solo architettonico ma anche culinario.

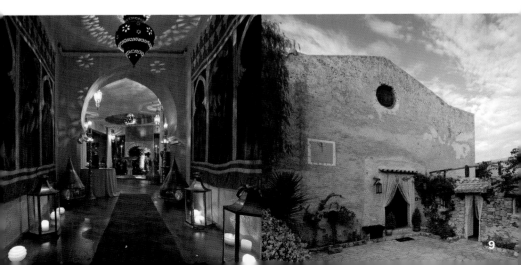

El Olivo

Architect: Orient Express Hotels | Chef: Guillermo Menéndez

Son Canals s/n | 07179 Deià, Mallorca
Phone: +34 971 639 011
www.hotel-laresidencia.com
Opening hours: Mon–Sun 1 pm to 3 pm, 8 pm to 11 pm
Average price: € 50
Cuisine: Mediterranean
Special features: Atmosphere of peace and tranquillity

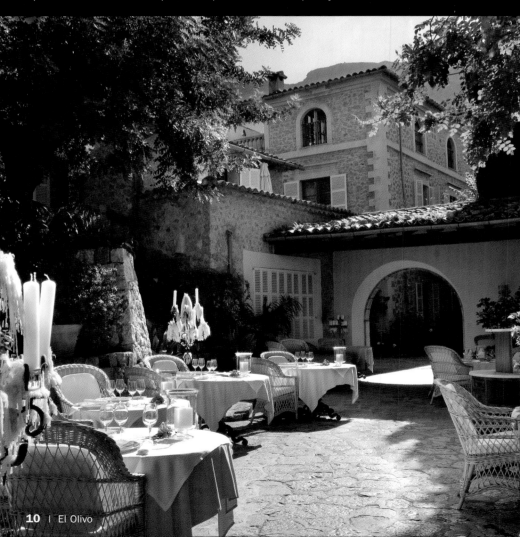

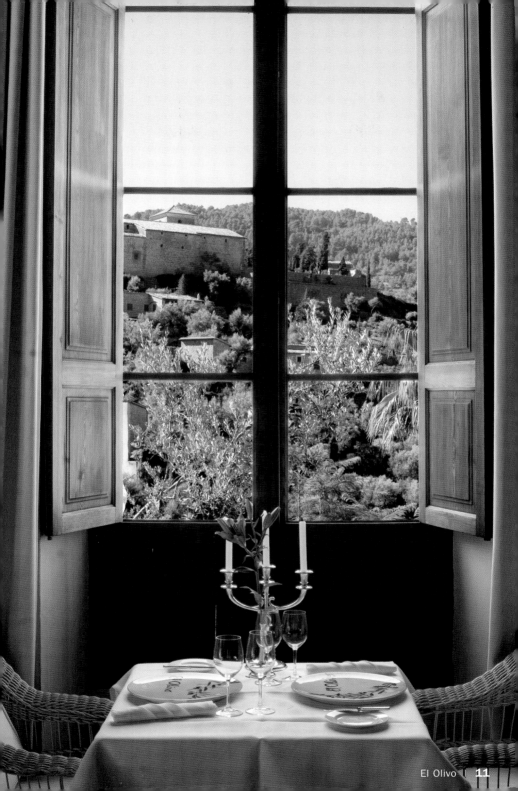

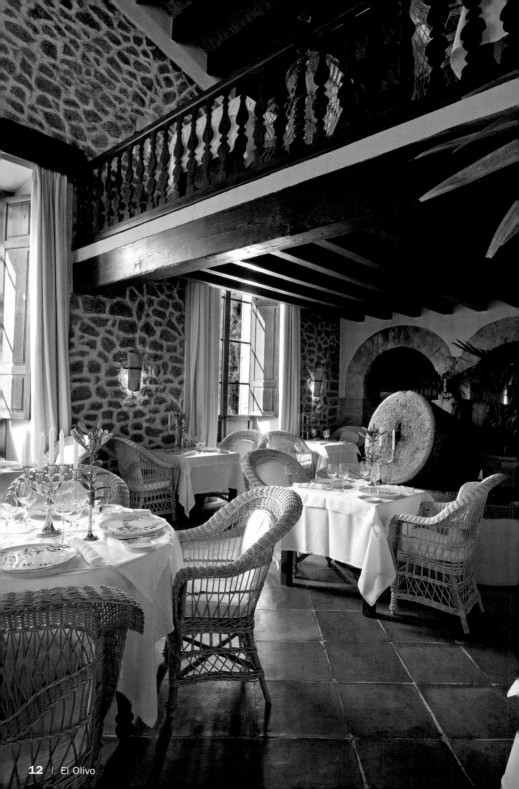

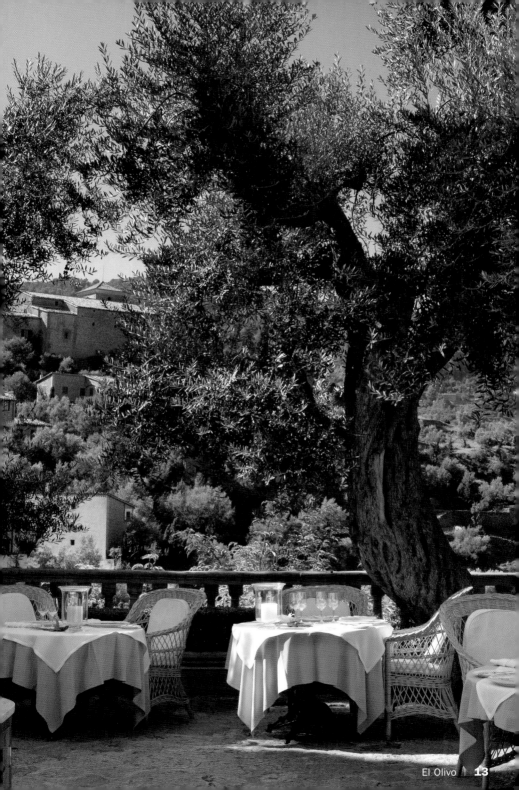

Bogavante

y lampuga en escabeche

Marinated Lobster and Dolphin-fish
Hummer und Goldmakrele in Marinade
Homard et coryphène en escabèche
Astice e lampuga in vinaigrette

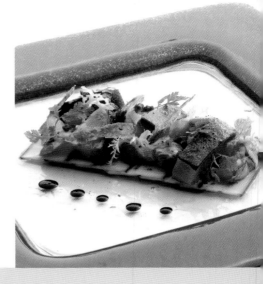

1 bogavante de 500 g aprox.
1 lampuga de 500 g aprox.
1 zanahoria cortada en juliana
1 puerro cortado en juliana
120 ml aceite de oliva
100 ml agua
120 ml vinagre
2 flores de lavanda
1 calabacín cortado en juliana
40 g de jengibre laminado
1 escarola rizada
50 g de tomates secos picados
30 g de fuet cortado en lonchas finas
Sal y pimienta

Hervir el bogavante y reservarlo. Limpiar y des-espinar la lampuga y marcar en una plancha los filetes por el lado de la piel. Preparar el escabe-che hirviendo la zanahoria y el puerro en 100 ml de aceite a fuego lento durante 15 minutos. De-jar enfriar y añadir el agua y 100 ml de vinagre. Salpimentar y hervir durante 2 minutos más. Marinar la lampuga en el escabeche durante 1 hora. Preparar una vinagreta con 20 ml de acei-te, 20 ml de vinagre y las flores de lavanda. Disponer la juliana de calabacín en el fondo del plato y regarlo con la vinagreta. Cortar la lampu-ga y el bogavante en trozos regulares y colocar-los encima del calabacín, intercalando las lámi-nas de jengibre y las hojas de escarola. Adornar con el tomate seco picado y el fuet.

1 lobster, approx. 1 lb 1 1/2 oz
1 dolphin-fish, approx. 1 lb 1 1/2 oz
1 julienne sliced carrot
1 julienne sliced leek
120 ml olive oil
100 ml water
120 ml vinegar
2 lavender flowers
1 julienne sliced zucchini
1 1/3 oz sliced ginger
1 endive
1 3/4 oz chopped dried tomatoes
1 oz sliced fuet (Catalonian cured sausage)
Salt and pepper

Boil the lobster and set aside. Clean the dol-phin-fish, bone, and sear the skin. Prepare the marinade by poaching the carrot and leek in 100 ml of oil on low heat for 15 minutes. Remove from heat and after cooling, add water and 100 ml of vinegar. Add salt and pepper and boil for 2 more minutes. Marinade the dolphin-fish in the mixture for approximately 1 hour. Pre-pare a vinaigrette out of 20 ml of oil, 20 ml of vinegar and the lavender flowers.
Place the sliced zucchini on a plate and pour the vinaigrette over it. Cut the dolphin-fish and lob-ster in even pieces, arrange over the zucchini in alternate layers with the slices of ginger and escarole leaves. Adorn with chopped dried toma-toes and fuet.

1 Hummer à 500 g
1 Goldmakrele à 500 g
1 Möhre, in Julienne geschnitten
1 Lauch, in Julienne geschnitten
120 ml Olivenöl
100 ml Wasser
120 ml Essig
2 Lavendelblüten
1 Zucchini, in Julienne geschnitten
40 g eingelegter Ingwer in Scheiben
1 gekräuselte Endivie
50 g getrocknete Tomaten, gehackt
30 g Fuet, in dünne Scheiben geschnitten
(Katalonische, geräucherte Hartwurst)
Salz und Pfeffer

Den Hummer kochen, schälen und zur Seite stellen. Die Goldmakrele reinigen, in Filets schneiden, entgräten und in einer heißen Pfanne anbraten. Für die Marinade; die Möhre und den Lauch in 100 ml Öl bei schwacher Hitze 15 Minuten dünsten. Abkühlen lassen. Wasser und 100 ml Essig hinzugeben, pfeffern, salzen und nochmals 2 Minuten köcheln lassen. Die Goldmakrele 1 Stunde lang in die Marinade einlegen. Aus den 20 ml Öl, den 20 ml Essig und den Lavendelblüten eine Vinaigrette zubereiten. Die Zucchini in Julienne auf einen Teller geben und mit der Vinaigrette begießen. Die Goldmakrele und den Hummer in gleichmäßige Stücke schneiden, abwechselnd mit Ingwerscheiben und Endivie belegen und mit Fuet und getrockneten Tomaten dekorieren.

1 homard d'environ 500 g
1 morceau de coryphène de environ 500 g
1 carotte coupée en julienne
1 poireau coupé en julienne
120 ml d'huile d'olive
100 ml d'eau
120 ml de vinaigre
2 fleurs de lavande
1 courgette coupée en julienne
40 g de gingembre confit
1 scarole frisée
50 g de tomates séchées émincées
30 g de miettes de fuet (saucisson catalan)
Sel et poivre

Cuire le homard dans l'eau bouillante et le réserver. Nettoyer et effiler la coryphène, faire dorer les filets du côté de la peau. Pour l'escabèche, faire revenir carotte et poireau dans 100 ml d'huile à feu doux 15 minutes. Laisser refroidir, ajouter eau et 100 ml de vinaigre. Poivrer, saler et laisser bouillir 2 minutes. Faire mariner la coryphène dans l'escabèche 1 heure. Préparer une vinaigrette avec 20 ml d'huile, 20 ml de vinaigre et les fleurs de lavande.
Disposer la julienne de courgette sur l'assiette et arroser de vinaigrette. Couper la coryphène et le homard en morceaux réguliers et les disposer au-dessus de la courgette. Intercaler les tranches de gingembre et la scarole. Ajouter l'émincé de tomate séchée et le fuet.

1 astice di 500 g circa
1 lampuga di 500 g circa
1 carota tagliata a julienne
1 porro tagliato a julienne
120 ml d'olio d'oliva
100 ml d'acqua
120 ml d'aceto
2 fiori di lavanda
1 zucchino tagliato a julienne
40 g di zenzero a scaglie
1 scarola riccia
50 g di pomodori secchi tritati
30 g di fuet tagliato a fette sottili (insaccato catalano affumicato)
Sale e pepe

Bollire l'astice, privarlo del guscio e metterlo da parte. Pulire la lampuga, tagliarla a filetti, deliscarli e scottarli in una padella. Preparare la vinaigrette facendo appassire a fuoco lento la carota e il porro in 100 ml d'olio per 15 minuti. Lasciar raffreddare e aggiungere l'acqua e 100 ml d'aceto. Salare, pepare e far cuocere a fuoco lento ancora per 2 minuti. Marinare la lampuga nella vinaigrette per 1 ora. Preparare una vinaigrette con 20 ml d'olio, 20 ml d'aceto e i fiori di lavanda.
Disporre la julienne di zucchino sul fondo del piatto e cospargerlo con la vinaigrette. Tagliare la lampuga e l'astice in pezzi regolari e disporli sullo strato di zucchini intercalando le scaglie di zenzero e la scarola. Decorare con il pomodoro secco tritato e il fuet.

Es Molí d'en Bou

Chef: Tomeu Caldentey Soler

c/ Sol, 13 | 07530 Sant Llorenç des Cardassar, Mallorca
Phone: +34 971 569 663
Opening hours: Mon–Sun 1:30 pm to 3:30 pm, 8 pm to 11 pm
Average price: € 30
Cuisine: Creative Mediterranean cuisine
Special features: Old grain mill restored with interesting architectural elements

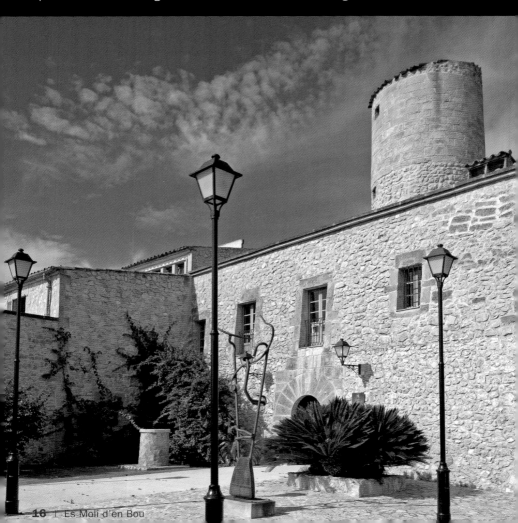

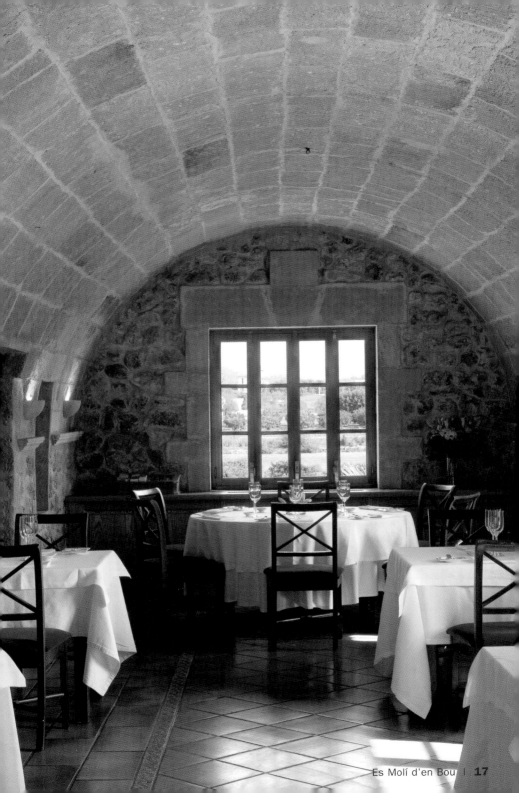

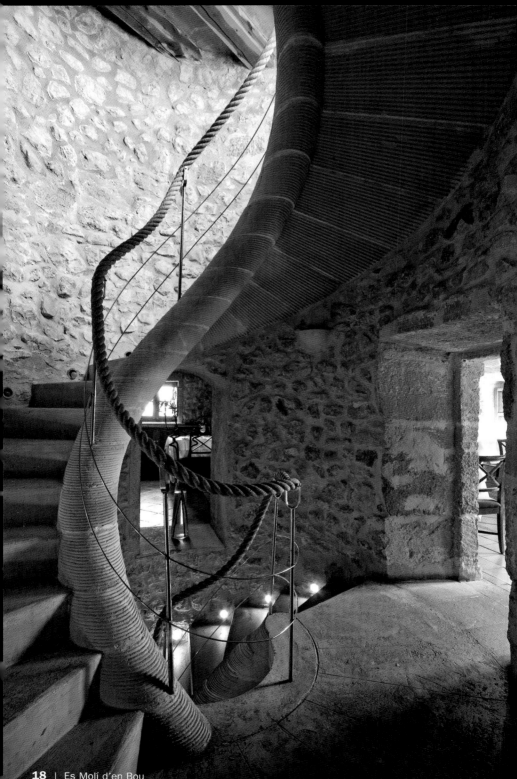

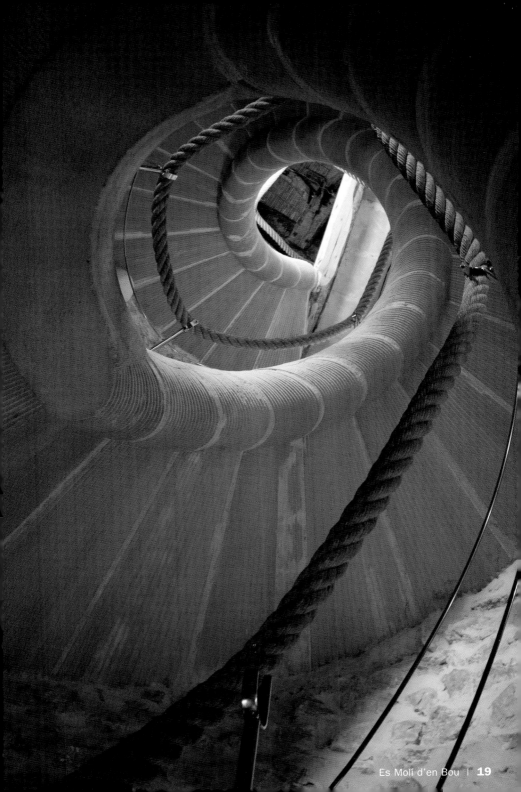

Gambas

con cuscús

Prawns with Couscous

Garnelen mit Couscous

Crevette royale au couscous

Gamberi con cuscus

250 ml de jarabe (150 ml agua + 100 g azúcar)
10 hojas de albahaca
4 hojas de gelatina
100 ml de agua
400 ml de zumo de tomate
25 g de tapioca
100 g de cuscús
50 g de tomate pelado cortado en dados
25 g de pimiento verde cortado en dados
25 g de cebolla cortada en dados
16 colas de gamba
Sal

Llevar a ebullición el jarabe, añadir las hojas de albahaca y cocer durante 3 minutos. Retirar del fuego y dejar reposar durante 15 minutos. Hi-dratar las hojas de gelatina en agua fría. Diluir la gelatina en la infusión de jarabe y albahaca y enfriar en el frigorífico durante 24 horas. Llevar a ebullición el zumo de tomate, añadir la tapioca y remover hasta que espese. Reservar. Ligar el cuscús con el tomate, el pimiento verde y la cebolla. Aplastar una cola de gamba y reducirla a una lámina de unos 2 mm, verter encima 1 cucharada de cuscús y formar una bola. Repetir la operación con las colas de gamba restantes. Disponer las bolas de gambas y cuscús en el centro del plato, coronar con la gelatina de albahaca cortada en dados y rociar con la salsa de tomate.

250 ml syrup (150 ml water + 3 1/2 oz sugar)
10 basil leaves
4 gelatin sheets
100 ml water
400 ml tomato juice
7/8 oz tapioca
3 1/2 oz couscous
1 3/4 oz peeled and chopped tomatoes
7/8 oz chopped green pepper
7/8 oz chopped onion
16 prawn tails
Salt

Bring the syrup to a boil, add the basil leaves and simmer for 3 minutes. Remove from heat and let cool for 15 minutes. Moisten the gelatin sheets in cold water. Dilute the gelatin in the basil syrup and cool in the refrigerator for 24 hours. Bring the tomato juice to a boil, add the tapioca and stir until thick. Set aside. Cook the couscous, let cool and mix with the tomato, green pepper and onion. Flatten a prawn tail until about 3/4 inch thick. Place 1 tbsp of couscous on top and shape into a ball. Repeat with the remaining prawns.
Place prawn and couscous balls in the center of the plate and top with cubes of basil jelly. Pour tomato sauce on top.

250 ml Sirup (150 ml Wasser + 100 g Zucker)
10 Basilikumblätter
4 Blätter Gelatine
100 ml Wasser
400 ml Tomatensaft
25 g Tapioka
100 g Couscous
50 g Tomate, geschält, gewürfelt und entkernt
25 g grüne Paprika, gewürfelt
25 g Zwiebel, gewürfelt
16 Garnelenschwänze
Salz

Den Sirup erhitzen, die Basilikumblätter hinzufügen und 3 Minuten köcheln lassen. Vom Feuer nehmen und 15 Minuten ruhen lassen. Die Gelatine in kaltem Wasser einweichen und in dem Basilikumaufguss auflösen. 24 Stunden lang im Kühlschrank abkühlen lassen. Den Tomatensaft in einem Topf erhitzen. Die Tapioka hinzugeben und den Saft unter ständigem Rühren binden. Zur Seite stellen. Den Couscous mit der Tomate, der grünen Paprika und der Zwiebel mischen. Einen Garnelenschwanz auf 2 mm Dicke pressen und mit 1 EL Couscous belegen. Eine Kugel formen. Das gleiche Verfahren mit den restlichen Garnelenschwänzen wiederholen. Die Garnelenschwanzkugeln in die Mitte eines Tellers legen, mit der gewürfelten Basilikumgelatine dekorieren und mit Tomatensauce übergießen.

250 g de sirop (150 ml eau + 100 g sucre)
10 feuilles de basilic
4 feuilles de gélatine
100 ml d'eau
400 ml de jus de tomate
25 g de tapioca
100 g de couscous
50 g de dés de tomate pelée, épépinée
25 g de dés de poivron vert
25 g de dés d'oignon
16 queues de crevette royale
Sel

Faire chauffer le sirop à feu doux, incorporer les feuilles de basilic et cuire 3 minutes. Retirer du feu et laisser reposer â couvert 15 minutes. Ramollir les feuilles de gélatine dans l'eau froide. La diluer dans le sirop au basilic et refroidir au réfrigérateur 24 heures. Amener le jus de tomate à ébullition, ajouter le tapioca et tourner jusqu'à ce qu'il épaississe. Réserver. Mélanger le couscous avec les dés de tomate, le poivron vert et l'oignon. Réduire une queue de crevette à une épaisseur d'env 2 mm, mettre 1 c. à soupe de couscous et former une boule. Répéter l'opération avec le reste des queues de crevette. Disposer les boules de crevettes et le couscous sur une assiette, décorer avec la gélatine au basilic coupée en dés et verser quelques gouttes de sauce tomate.

250 ml sciroppo (150 ml d'acqua + 100 g di zucchero)
10 foglie di basilico
4 fogli di gelatina
100 ml d'acqua
400 ml di succo di pomodoro
25 g di tapioca
100 g di cuscus
50 g di pomodori sbucciati tagliati a dadi
25 g di peperone verde tagliato a dadi
25 g di cipolla tagliata a dadi
16 code di gambero
Sale

Far bollire lo sciroppo, aggiungere le foglie di basilico e cuocere a fuoco lento per 3 minuti. Togliere dal fuoco e lasciar riposare per 15 minuti. Idratare i fogli di gelatina in acqua fredda. Sciogliere la gelatina nell'infusione di sciroppo e basilico e metterla in frigorifero per 24 ore. Far bollire il succo di pomodoro, aggiungere la tapioca e mescolare fino ad ottenere una salsa gelatinosa. Mettere da parte. Mescolare il cuscus con il pomodoro, il peperone verde e la cipolla. Schiacciare una coda di gambero e ridurla a una lamella di circa 2 mm di spessore, collocarvi sopra 1 cucchiaio di cuscus e farne una pallina. Ripetere il procedimento con le rimanenti code di gambero. Disporre le palline di gambero e cuscus al centro del piatto, sistemare tutto attorno la gelatina di basilico tagliata a dadi e spruzzare il tutto con la salsa di pomodoro.

La Reserva Rotana

Interior design: Princess Loretta zu Sayn-Wittgenstein
Chef: Jörg Kocher

Camí de S'Avall, km 3 I 07500 Manacor, Mallorca
Phone: +34 971 845 685
www.reservarotana.com
Opening hours: Mon–Sun 1 pm to 4 pm, 7 pm to 11 pm
Average price: € 20
Cuisine: Mediterranean and international cuisine
Special features: Wine from the in-house wine cellar, farmyard and market products, pleasant courtyard and dishes available for vegetarians and allergy sufferers

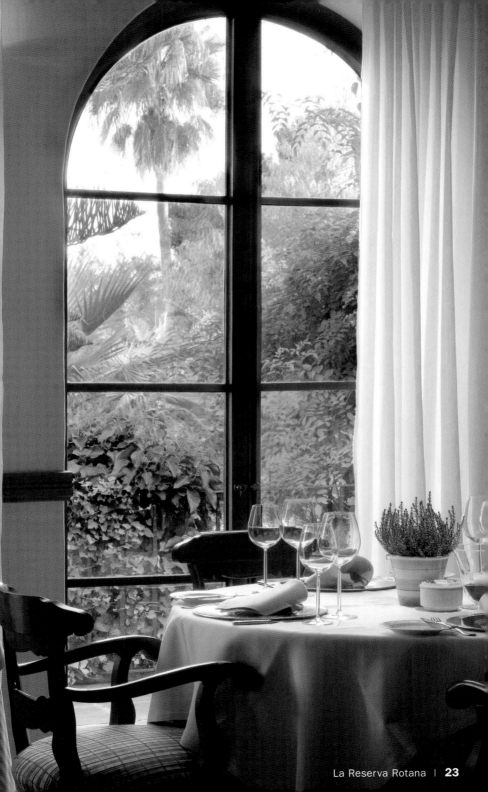

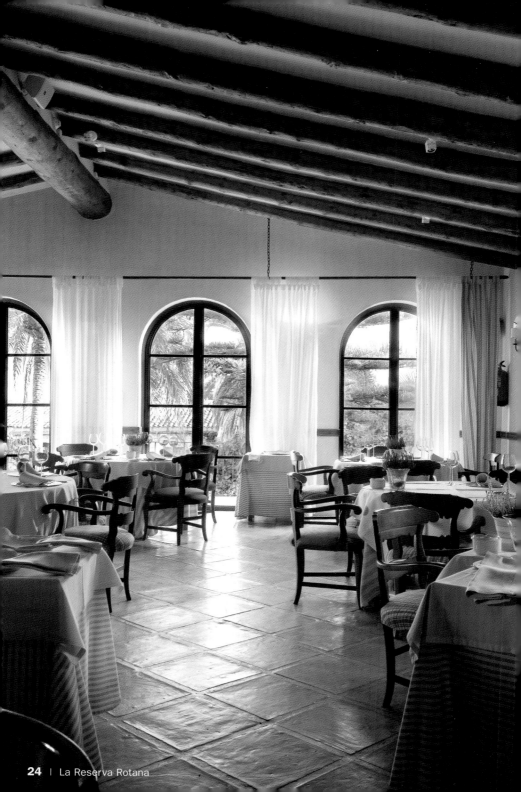

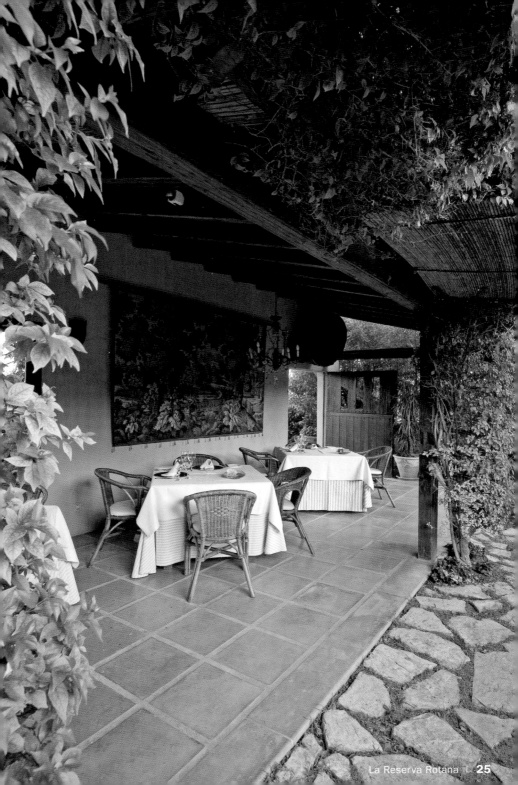

Variaciones
de plátano

Banana Variation

Variationen mit Banane

Variations à la banane

Variazioni di banana

Helado de plátano: 2 plátanos maduros, 50 g de azúcar, 250 ml de leche, 100 ml de nata, 3 yemas de huevo, 25 g de maicena, 2 cucharadas de leche, 2 hojas de gelatina, 50 g de cobertura blanca, 50 ml de ron
Caramelizar el azúcar en un cazo y a continuación añadir los plátanos laminados, la leche y la nata. Hervir y mezclar con las yemas, la maicena y 2 cucharadas de leche durante 5 minutos. Agregar la gelatina remojada, la cobertura y el ron. Congelar.

Parfait de plátano: el puré de 1 plátano maduro, 2 yemas de huevo, 25 ml de vino blanco, 25 g de azúcar, 25 ml de ron, 50 g de cobertura blanca, 2 hojas de gelatina, 2 claras de huevo, 100 ml de nata

Batir las yemas con el vino blanco, el azúcar y el ron. Mezclar la cobertura, la gelatina remojada y el puré de plátano. Montar las claras y la nata. Ligar las mezclas y congelar.

Espuma de plátano: 50 g de puré de plátano, 100 ml de nata, 100 g de cobertura blanca, una pizca de jengibre en polvo, 50 g de yogurt natural
Calentar la nata junto con la cobertura, el puré y el jengibre. Agregar el yogurt y montar la mezcla.

Banana ice cream: 2 ripe bananas, 1 3/4 oz sugar, 250 ml milk, 100 ml single cream, 3 egg yolks, 7/8 oz corn starch, 2 tbsp milk, 2 sheets of gelatin, 1 3/4 oz white chocolate, 50 ml rum
Caramelize the sugar in a sauce pan and then add the bananas, the milk and cream. Boil and mix with the egg yolks, the corn starch, and 2 tbsp of milk for 5 minutes. Add the pre-soaked gelatine, the white chocolate and the rum. Freeze.

Banana parfait: the purée of 1 ripe banana, 2 egg yolks, 25 ml white wine, 7/8 oz sugar, 25 ml rum, 1 3/4 oz white chocolate, 2 sheets of gelatine, 2 egg whites, 100 ml cream

Beat the egg yolks with sugar, the white wine, and rum. Mix the chocolate with the pre-soaked gelatine and banana purée. Beat the egg whites and cream and carefully fold into the mass. Pour into a mould and freeze.

Banana foam: 1 3/4 oz banana puree, 100 ml cream, 3 1/2 oz white chocolate, a pinch of powdered ginger, 1 3/4 oz natural yoghurt
Heat the cream with the chocolate, the puree and the ginger powder. Add the yoghurt and whip.

Bananeneis: 2 reife Bananen, 50 g Zucker, 250 ml Milch, 100 ml Sahne, 3 Eigelb, 25 g Maismehl, 2 EL Milch, 2 Blatt Gelatine, 50 g weiße Kuvertüre, 50 ml Rum
Den Zucker in einem Topf karamellisieren, die in Scheiben geschnittenen Bananen sowie Milch und Sahne hinzufügen. 5 Minuten aufkochen lassen und mit dem Eigelb, der Maisstärke und 2 EL Milch mischen. Die eingeweichte Gelatine hinzugeben und mit der Kuvertüre und dem Rum mischen. Einfrieren.

Bananenparfait: Püree einer reifen Banane, 2 Eigelb, 25 ml Weißwein, 25 g Zucker, 25 ml Rum, 50 g weiße Kuvertüre, 2 Blätter Gelatine, 2 Eiweiß, 100 ml Sahne.

Das Eigelb mit dem Zucker, dem Weißwein und dem Rum vermischen und schaumig schlagen. Die Kuvertüre mit der eingeweichten Gelatine und dem Bananenpüree mischen. Das Eiweiß und die Sahne schlagen und alles vorsichtig vermischen. Einfrieren.

Bananenschaum: 50 g Bananenpüree, 100 ml Sahne, 100 g weiße Kuvertüre, eine Prise Ingwerpulver, 50 g Naturjoghurt.
Die Sahne mit der Kuvertüre, dem Püree und dem Ingwerpulver erhitzen. Den Joghurt dazugeben und die Masse schlagen.

Glace à la banane : 2 bananes mûres, 50 g de sucre, 250 ml de lait, 100 ml de crème liquide, 3 jaunes d'œuf, 25 g de maïzena, 2 c. à soupe de lait, 2 feuilles de gélatine, 50 g de couverture blanche, 50 ml de rhum
Caraméliser le sucre dans une casserole, ajouter les bananes en tranches, le lait et la crème. Porter à ébullition 5 minutes et mélanger avec les jaunes d'œuf, la maïzena et 2 c. à soupe de lait. Enfin, ajouter la gélatine ramollie, la couverture et le rhum. Congeler.

Parfait à la banane : la purée de 1 banane mûre, 2 jaunes d'œuf, 25 ml de vin blanc, 25 g de sucre, 25 ml de rhum, 50 g de couverture blanche, 2 feuilles de gélatine, 2 blancs d'œuf, 100 ml de crème liquide

Fouetter les jaunes d'œuf avec le sucre, le vin blanc et le rhum. Mélanger la couverture avec la gélatine ramollie et la purée de banane. Monter les blancs en neiges, fouetter la crème et incorporer les deux au mélange. Mettre dans un moule et congeler.

Mousse de banane : 50 g de purée de banane, 100 ml de crème, 100 g de couverture blanche, une 1 pincée de gingembre en poudre, 50 g de yaourt (nature)
Chauffer la crème avec la couverture, la purée et la poudre de gingembre. Ajouter le yaourt et faire monter.

Gelato alla banana: 2 banane mature, 50 g di zucchero, 250 ml di latte, 100 ml di panna, 3 tuorli d'uovo, 25 g di maizena (fecola di mais), 2 cucchiai di latte, 2 fogli di gelatina, 50 g di copertura bianca, 50 ml di rum
Caramellare lo zucchero in un pentolino, poi aggiungere le banane tagliate a lamelle, il latte e la panna. Far bollire e mescolare con i tuorli, la maizena e 2 cucchiai di latte per 5 minuti. Aggiungere la gelatina ammollata, la copertura e il rum. Congelare.

Parfait di banana: la purea di 1 banana matura, 2 tuorli d'uovo, 25 ml di vino bianco, 25 g di zucchero, 25 ml di rum, 50 g di copertura bianca, 2 fogli di gelatina, 2 albumi d'uovo, 100 ml di panna

Montare i tuorli con lo zucchero, il vino bianco e il rum. Mescolare la copertura con la gelatina ammollata e la purea di banana. Montare i tuorli e la panna. Amalgamare le miscele e congelare.

Schiuma di banana: 50 g di purea di banana, 100 ml di panna, 100 g di copertura bianca, un pizzico di zenzero in polvere, 50 g di yogurt naturale
Scaldare la panna assieme alla copertura, la purea e lo zenzero. Aggiungere lo yogurt e montare il composto.

Living

Architect: Cristian Bazin, Estefan Marrie | Chef: Tsigaras Michail

c/ Cotoner, 47 | 07013 Palma de Mallorca, Mallorca
Phone: +34 971 455 268
Opening hours: Mon–Sun 1:30 pm to 4 pm, 8:30 pm to midnight
Average price: € 35–40
Cuisine: Mediterranean
Special features: Restaurant with relaxed atmosphere, perfect for couples

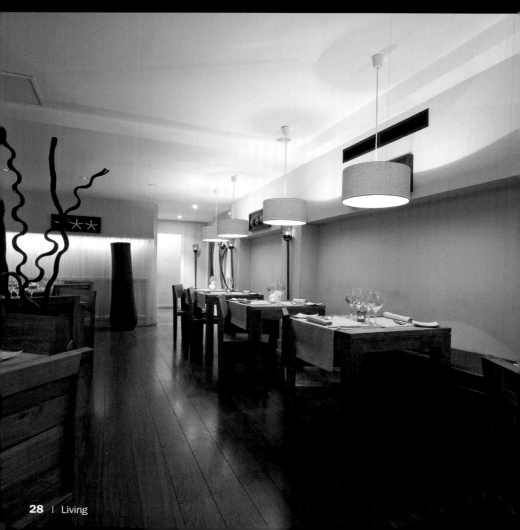

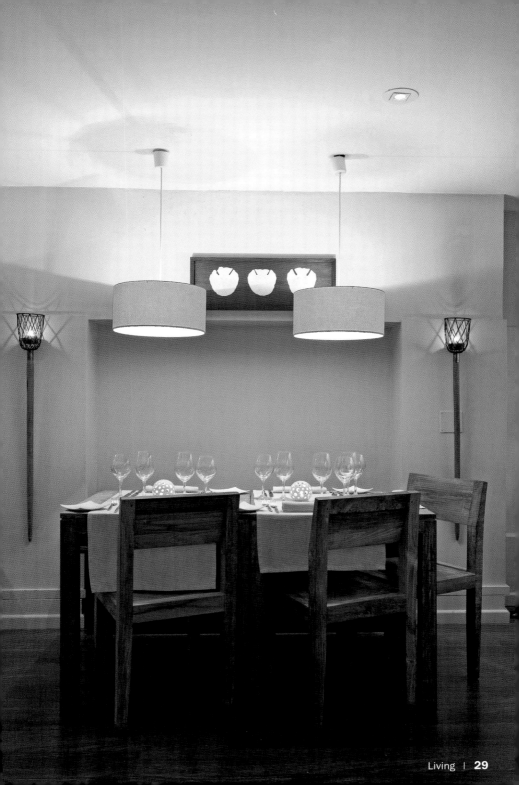

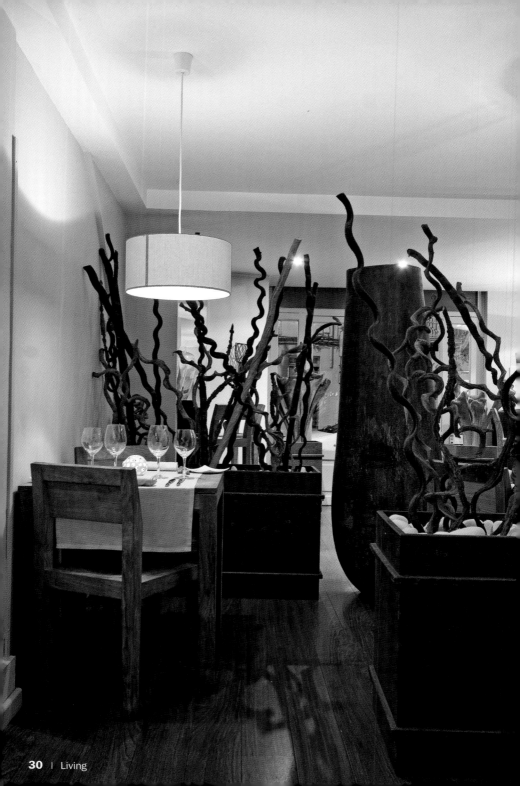

L'Orangerie

Architect: Antonio Obrador | Chef: Christian Rullán

Gran Hotel Son Net, c/ Castillo de Sonnet s/n | 07194 Puigpunyent, Mallorca
Phone: +34 971 147 000
www.sonnet.es
Opening hours: Mon–Sun Apr 15th–Oct 31st 8 pm to 11 pm, Nov 1st–Apr 14th
1 pm to 3:30 pm and 8 pm to 10:30 pm
Average price: € 40
Cuisine: Mediterranean
Special features: The restaurant is housed in a perfectly preserved hundred years
old olive oil press

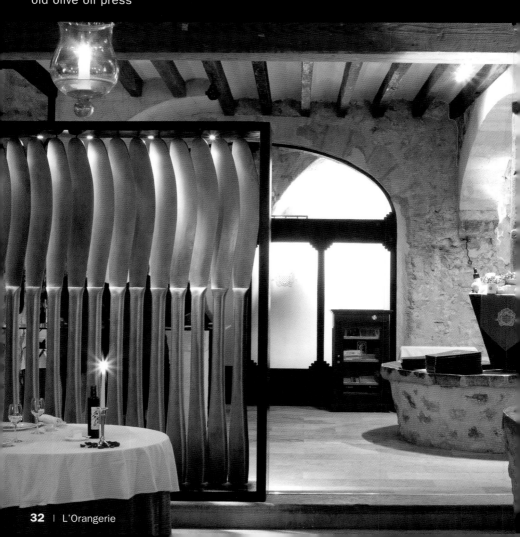

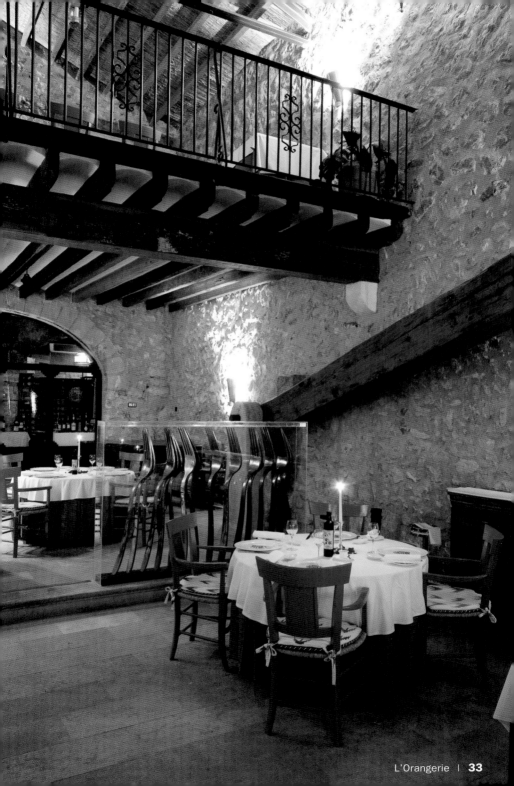

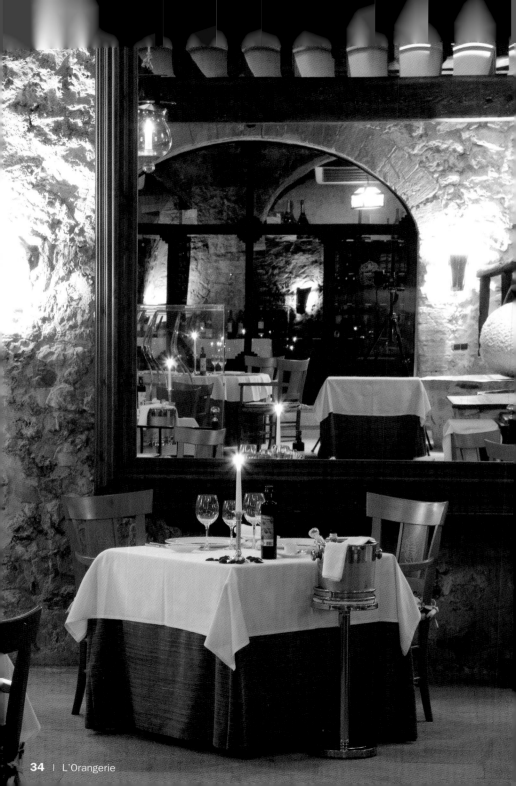

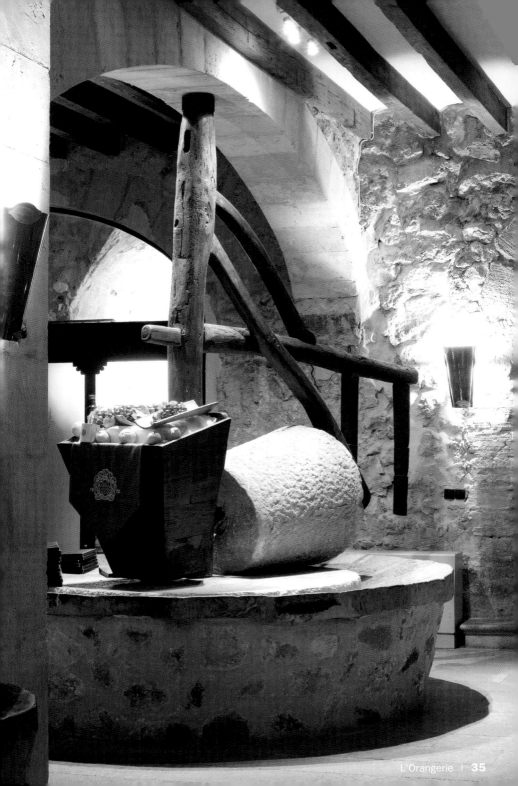

Cabracho

a la mallorquina

Majorcan-style Scorpion Fish

Roter Drachenkopf auf
mallorquinische Art

Rascasse rouge à la majorquine

Scorfano rosso alla maiorchina

1 1/2 kg de cabracho
1 calamar
1 pimiento rojo
1 champiñón grande
4 tomates confitados
2 dientes de ajo
1 rebanada de pan de molde
250 g de acelgas
1 cebolla blanca
50 g de queso parmesano rallado
2 yemas de huevo
100 ml de caldo de pescado
200 ml de aceite de oliva
Sal

Trocear el calamar, el pimiento rojo, el champi-
ñón y los tomates confitados. Laminar el ajo.
Cortar la acelga y la cebolla en juliana. En una
sartén con 150 ml de aceite saltear cada ingre-
diente por separado. Cortar el pan de molde en
dados y freírlos en 50 ml de aceite. Verter los
ingredientes en un recipiente y añadir el queso
parmesano, las yemas de huevo y el caldo de
pescado reducido. Rectificar de sal y ligar hasta
obtener una masa homogénea. Limpiar y des-
espinar el cabracho. Rellenarlo con la masa y
hornearlo a 250 °C durante 1/2 hora.
Servir caliente y regar con unas gotas de aceite
de oliva.

3 lb 4 1/2 oz large scorpion fish
1 squid
1 red pepper
1 large mushroom
4 pickled tomatoes
2 garlic cloves
1 slice of bread
8 3/4 oz silver beet
1 white onion
1 3/4 oz grated parmesan cheese
2 egg yolks
100 ml fish stock
200 ml olive oil
Salt

Cut the squid, red pepper, mushroom and pick-
led tomatoes into pieces and slice the garlic.
Cut the silver beet and the onion into julienne
slices. In a frying pan with 150 ml olive oil,
sauté each ingredient separately. Cut the bread
into cubes and fry in 50 ml olive oil. Place every-
thing in a bowl and add the parmesan, egg yolks
and reduced fish broth. Add salt and knead un-
til obtaining a homogeneous mass. Clean and
bone the scorpion fish. Fill with the stuffing and
bake in the oven for 1/2 hour at 480 °F.
Serve hot and dress with a splash of olive oil.

1 1/2 kg Roter Drachenkopf
1 Tintenfisch
1 rote Paprikaschote
1 großer Champignon
4 eingelegte Tomaten
2 Knoblauchzehen
1 Scheibe Toastbrot
250 g Mangold
1 weiße Zwiebel
50 g geriebener Parmesan
2 Eigelb
100 ml Fischbrühe
200 ml Olivenöl
Salz

Den Tintenfisch, die rote Paprikaschote, d
Champignon und die eingelegten Tomaten i
Stücke und den Knoblauch in Scheiben schn
den. Den Mangold und die Zwiebel in Julien
schneiden. In einer Pfanne mit 150 ml Olive
alle Zutaten einzeln garschwenken. Das Toa
brot in Würfel schneiden und in 50 ml Olive
rösten. Alle Zutaten in ein Gefäß geben und (
Parmesan, das Eigelb und die eingekoc
Fischsuppe hinzugeben. Salzen und gut du
mischen. Den Roten Drachenkopf säubern (
entgräten. Mit der Mischung füllen und im O
bei 250 °C eine 1/2 Stunde lang backen.
Heiß servieren und mit ein paar Tropfen Oli
öl begießen.

1 1/2 kg de rascasse rouge
1 calamar
1 poivron rouge
1 gros champignon
4 tomates confites
2 gousses d'ail
1 tranche de pain de mie
250 g de bettes
1 oignon blanc
50 g de parmesan râpé
2 jaunes d'œuf
100 ml de sauce de poisson
200 ml d'huile d'olive
Sel

Couper le calamar, le poivron rouge, le ch
pignon et les tomates confites en petits
ceaux et émincer l'ail. Couper les bettes et
gnon en julienne et réserver. Dans
sauteuse, faire revenir tous les ingrédients
parément dans 150 ml d'huile d'olive. Coup
pain de mie en petits cubes et les faire
dans 50 ml d'huile d'olive. Verser tous les i
dients dans un récipient et ajouter le parme
les jaunes d'œuf et la soupe de poisson réd
Resaler si nécessaire et mélanger jusqu'à
tention d'une farce homogène. Farcir la ras
se rouge, la déposer sur un tôle et la faire
au four à 250 °C pendant 1/2 heure.
Servir chaud et arroser de quelques goutte
huile d'olive.

1 1/2 kg di scorfano rosso
1 calamaro
1 peperone rosso
1 champignon grande
4 pomodori confettati
2 spicchi d'aglio
1 fetta di pane in cassetta
250 g di bietole
1 cipolla bianca
50 g di parmigiano grattugiato
2 tuorli d'uovo
100 ml di brodo di pesce
200 ml d'olio d'oliva
Sale

Tagliare a pezzi il calamaro, il peperone r
lo champignon e il pomodoro confettato. T
re l'aglio a rondelle e la bietola e la cipc
julienne. In una padella con 150 ml d'olio
re separatamente ogni ingrediente. Tagli
pane in cassetta a cubetti e friggerli in !
d'olio. Versare gli ingredienti in un recipie
aggiungere il parmigiano, i tuorli d'uovc
brodo ristretto di pesce. Correggere di s
amalgamare il tutto fino ad ottenere un cc
sto omogeneo. Pulire lo scorfano e delis
Farcirlo con il composto e cuocerlo in fo
250 °C per 1/2 ora.
Servire caldo e cospargere con delle goco
lio d'oliva.

Montenegro

Architect: Elena Saez Santamaría | Chef: Robert Deyhle

Montenegro, 10 | 07012 Palma de Mallorca, Mallorca
Phone: +34 971 728 957
Opening hours: Mon–Fri 1 pm to 3:45 pm, 8 pm to 11 pm, Sat 8 pm to midnight
Average price: € 32–35
Cuisine: Market, Mediterranean
Special features: Old Majorcan wine cellar

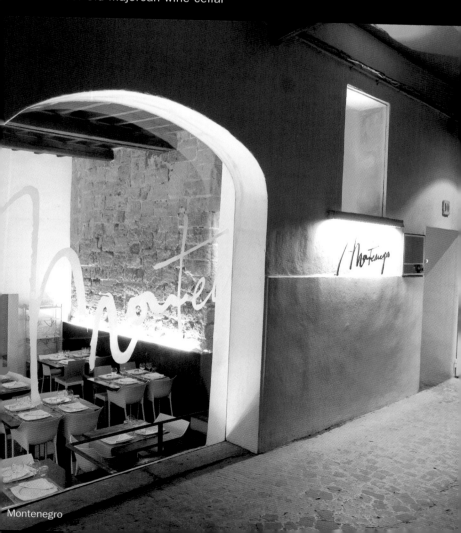

Montenegro

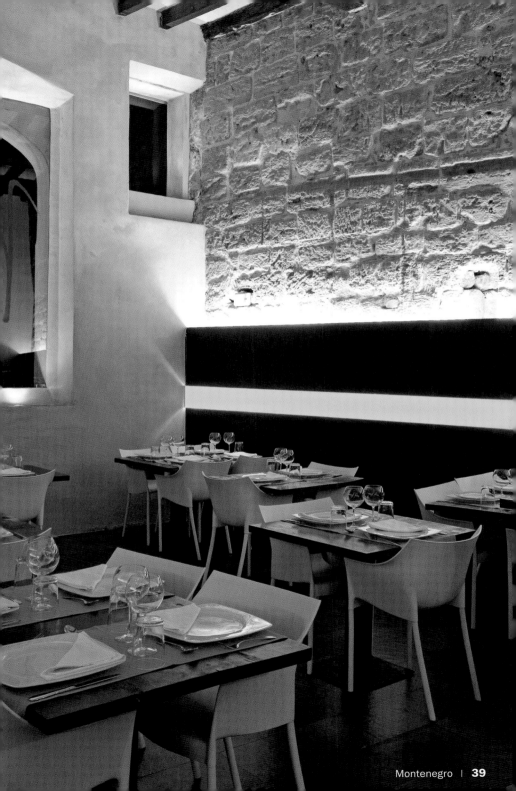

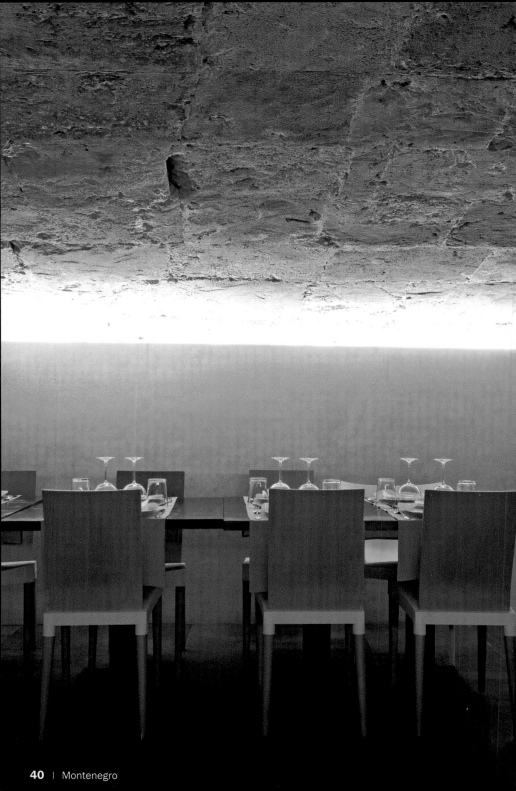

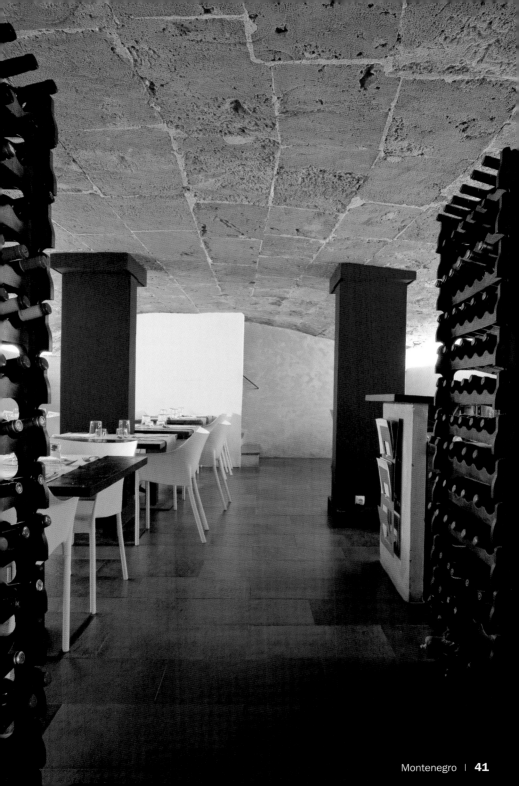

Rodaballo

sobre lecho de espinacas

Turbot on a Bed of Spinach
Steinbutt auf Spinatbett
Turbot sur lit d'épinards
Rombo su letto di spinaci

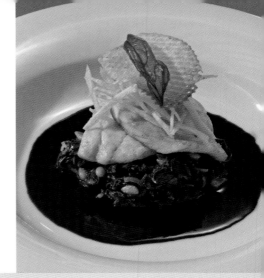

1 filete de rodaballo
250 g de espinacas
50 ml de vino tinto
50 g de azúcar moreno
25 ml de vinagre balsámico
1 chalote
150 g de mantequilla
1 patata
200 ml de aceite de oliva
1 diente de ajo picado
3 g de pimienta blanca
3 g de nuez moscada en polvo
50 g de piñones
Sal

Limpiar y cocer las espinacas. Reducir el vino tinto junto con el azúcar moreno y el vinagre durante 15 minutos. Freír el filete de rodaballo en una sartén con 30 g de mantequilla. Trocear el chalote y saltearlo junto con las espinacas en otra sartén untada con 50 g de mantequilla. Calentar la reducción de vino a 70 °C y añadir la mantequilla restante en pequeños trozos. Mezclar hasta obtener una salsa espesa. Cortar la patata en juliana y freírla en 200 ml de aceite de oliva. Disponer las espinacas en el centro del plato, condimentar con ajo, pimienta blanca, nuez moscada, piñones y sal. Colocar encima el filete de rodaballo y rociar con la salsa. Decorar con las patatas fritas.

1 turbot filet
8 3/4 oz spinach
50 ml red wine
1 3/4 oz brown sugar
25 ml balsamic vinegar
1 shallot
5 1/4 oz butter
1 potato
200 ml olive oil
1 chopped garlic clove
1/10 oz white pepper
1/10 oz nutmeg powder
1 3/4 oz pine nuts
Salt

Clean and boil the spinach. Reduce the red wine with the brown sugar and vinegar for 15 minutes. Lightly fry the turbot filet in a pan with 1 oz butter. Cut the shallot and sauté with the spinach in another pan coated with 1 3/4 oz butter. Heat the reduced wine to 160 °F and add the remaining pieces of butter. Mix until obtaining a thick sauce. Lastly, cut the potatoes in julienne and fry in 200 ml oil.
Place the spinach in the center of the plate and season with garlic, white pepper, nutmeg, pine nuts and salt. Place the turbot filet on top and dress with the sauce. Decorate with the fried potatoes.

1 Steinbutt
250 g Spinat
50 ml Rotwein
50 g brauner Zucker
25 ml Balsamicoessig
1 Schalotte
150 g Butter
1 Kartoffel
200 ml Olivenöl
1 gehackte Knoblauchzehe
3 g weißer Pfeffer
3 g geriebene Muskatnuss
50 g Pinienkerne
Salz

Den Spinat waschen und kochen. Den Rotwein zusammen mit dem braunen Zucker und dem Essig 15 Minuten reduzieren lassen. Den Steinbutt in einer Pfanne mit 30 g Butter braten. Die Schalotte hacken und zusammen mit dem Spinat in einer anderen Pfanne mit 50 g Butter sautieren. Den reduzierten Wein auf 70 °C erhitzen und mit den restlichen Butterstückchen zu einer Soße binden. Die Kartoffel in Julienne schneiden und in 200 ml Öl frittieren.
Den Spinat in die Mitte eines Tellers geben und mit Knoblauch, Salz, weißem Pfeffer, Muskatnuss und Pinienkernen würzen. Die Steinbuttfilets darauf geben und mit der Sauce übergießen. Mit den frittierten Kartoffeln dekorieren.

1 filet de turbot
250 g d'épinards
50 ml de vin rouge
50 g de sucre roux
25 ml de vinaigre balsamique
1 échalote
150 g de beurre
1 pomme de terre
200 ml d'huile d'olive
1 gousse d'ail finement hachée
3 g de poivre blanc
3 g de noix de muscade en poudre
50 g de pignons de pin
Sel

Nettoyer et ébouillanter les épinards. Réduire le vin rouge avec le sucre roux et le vinaigre 15 minutes. Faire revenir le filet de turbot dans une sauteuse dans 30 g de beurre. Dans une poêle, faire sauter l'échalote et les épinards dans 50 g de beurre. Faire chauffer la réduction de vin à 70 °C, ajouter le beurre en petits morceaux et mélanger jusqu'à obtention d'une sauce épaisse. Couper la pomme de terre en julienne et la frire dans 200 ml d'huile.
Disposer les épinards sur une assiette creuse et assaisonner avec ail, sel, poivre blanc, noix de muscade et pignons de pin. Placer au-dessus les filets de turbot et arroser de sauce. Décorer avec les pommes de terre frites.

1 filetto di rombo
250 g di spinaci
50 ml di vino rosso
50 g di zucchero di canna
25 ml di aceto balsamico
1 scalogno
150 g di burro
1 patata
200 ml d'olio d'oliva
1 spicchio d'aglio tritato
3 g di pepe bianco
3 g di noce moscata in polvere
50 g di pinoli
Sale

Pulire e lessare gli spinaci. Ridurre il vino rosso assieme allo zucchero di canna e all'aceto per 15 minuti. Rosolare in una padella con 30 g di burro il filetto di rombo. Tagliare lo scalogno a pezzetti e saltarlo assieme agli spinaci in un'altra padella unta con 50 g di burro. Riscaldare la riduzione di vino fino a raggiungere i 70 °C e aggiungervi il burro rimanente a piccoli pezzi. Mescolare fino ad ottenere una salsa densa. Tagliare la patata a julienne e friggerla in 200 ml d'olio d'oliva.
Disporre gli spinaci al centro del piatto, condire con aglio, pepe bianco, noce moscata, pinoli e sale. Collocarvi sopra il filetto di rombo e cospargere con la salsa. Decorare con le patate fritte.

Opio

Architect: Katarina and Eric van Brabandt,
K&E Interior Design AB | Chef: Nicolas Malenchini

c/ Montenegro, 12 | 07012 Palma de Mallorca, Mallorca
Phone: +34 971 425 450
www.purohotel.com
Opening hours: Mon–Sun 8 pm to 11:30 pm
Average price: € 40
Cuisine: Mediterranean and Asian
Special features: Informal ambience, created thanks to the DJ's eclectic choice

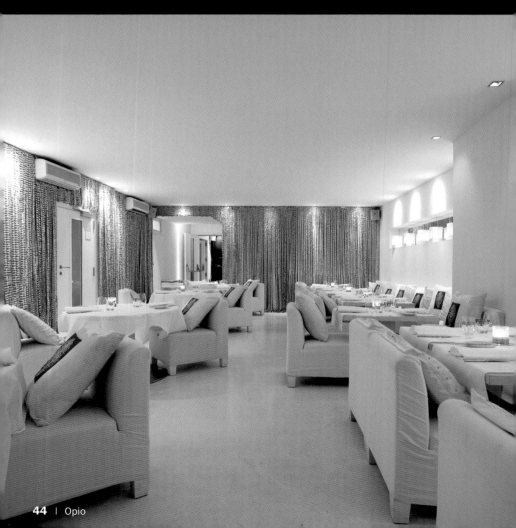

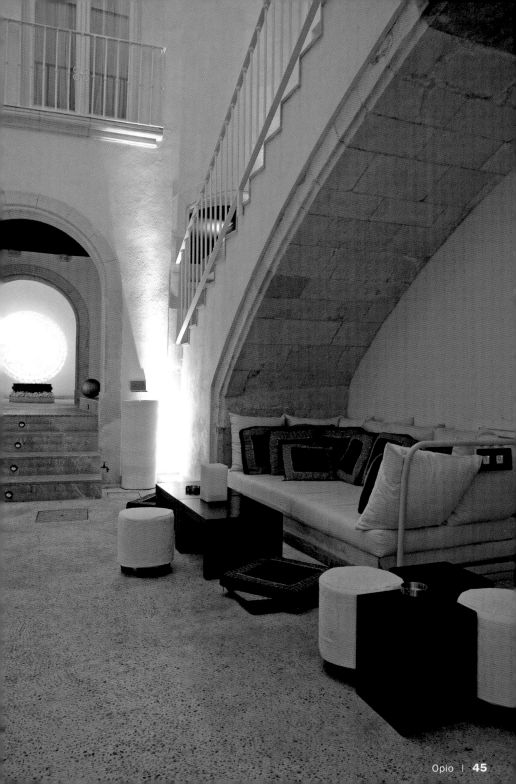

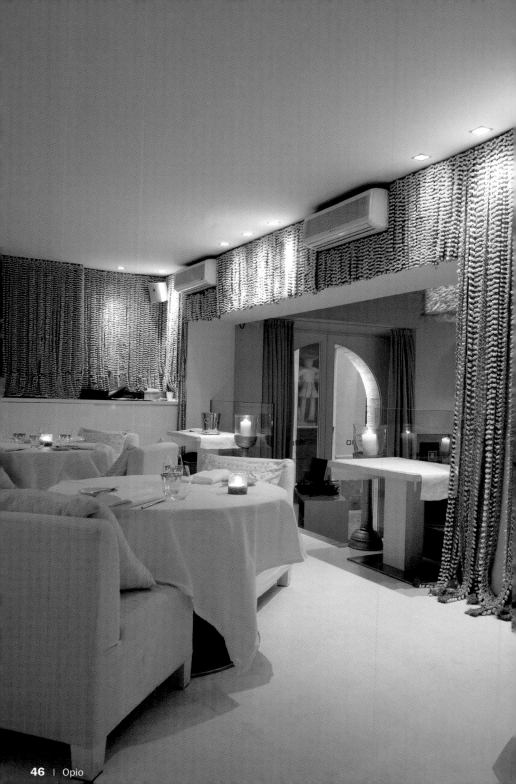

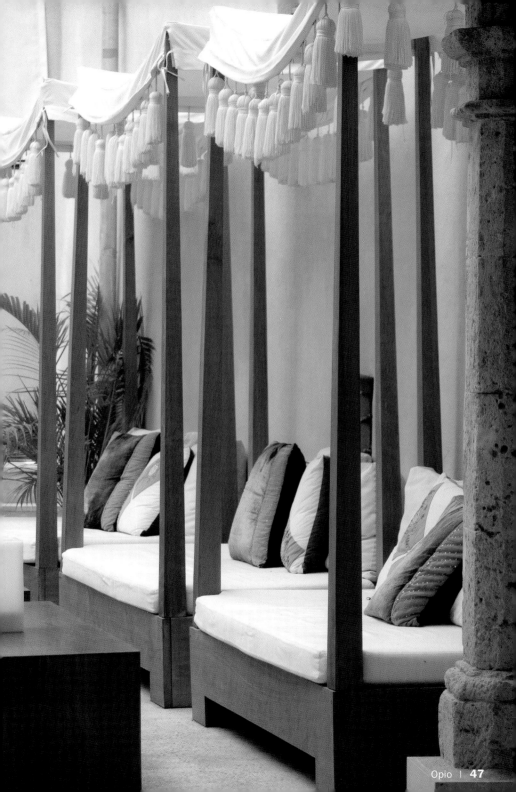

Entrecot Tataki

Tataki Sirloin Steak
Entrecôte-Tataki
Entrecôte Tataki
Entrecôte Tataki

150 g de entrecot
1/2 cebolla
1 pimiento rojo
1 tomate
2 dientes de ajo
2 cucharadas de aceite de oliva
1 raíz de loto
250 ml de agua
100 ml de vinagre de vino blanco
25 g de azúcar
6 ramas de cilantro
1 chili picado
Sal
50 g de guarnición: zanahoria, chayote y daikon
(rábano blanco) en juliana

Picar 1/2 cebolla, 1 pimiento rojo, 1 tomate y 2 dientes de ajo, y rehogarlos en una sartén con aceite durante 5 minutos. Cortar el entrecot en filetes muy finos, colocar un poco de sofrito en un extremo de cada uno y enrollarlos. Calentar en la sartén unas gotas de aceite y freír los filetes enrollados durante 5 minutos, dejar enfriar, cortar cada rollo en 4 cilindros del mismo tamaño y disponerlos en un plato. Pelar el loto, cortarlo en rodajas y cocerlo en una olla con agua y sal durante 20 minutos. Preparar una mezcla de agua, vinagre, sal, azúcar, 6 ramas de cilantro y 1 chili, y sumergir el loto en esta marinada.
Regar los cilindros de carne con la salsa de loto y decorar con la zanahoria, el chayote y el daikon cortados en juliana.

5 1/4 oz sirloin steak
1/2 onion
1 red pepper
1 tomato
2 garlic cloves
2 tbsp olive oil
1 lotus root
250 ml water
100 ml white wine vinegar
7/8 oz sugar
6 coriander sprigs
1 chili pepper, chopped
Salt
1 3/4 oz garnish: carrot, shallot and daikon (Japanese radish), julienne sliced

Chop 1/2 onion, 1 red pepper, 1 tomato and 2 garlic cloves and lightly fry in a bit of oil for 5 minutes. Cut the sirloin steak into fine slices, place a portion of the fried mix at one end of each slice and roll up the meat. Heat a few drops of oil in a pan and sear for 5 minutes. Leave to cool and cut each roll into 4 evenly sized cylinder shapes and serve on a plate. Peel the lotus root, slice and boil in a pan with salted water for 20 minutes. Prepare a mix of water, vinegar, salt, sugar, 6 coriander sprigs and 1 chili pepper. Drain the lotus root and submerge it in the marinade.
Pour the lotus sauce over the meat and decorate with a bouquet of finely sliced carrot, shallot and daikon.

150 g Entrecôte
1/2 Zwiebel
1 rote Paprika
1 Tomate
2 Knoblauchzehen
2 EL Olivenöl
1 Lotuswurzel
250 ml Wasser
100 ml Weißweinessig
25 g Zucker
6 Korianderzweige
1 gehackte Chili
Salz
50 g Beilagen: Möhre, Chayote und Daikon
(Japanischer Rettich) in Julienne geschnitten

Eine 1/2 Zwiebel, 1 Paprika, 1 Tomate und 2 Knoblauchzehen klein schneiden und in der Pfanne 5 Minuten lang anbraten. Das Entrecôte in dünne Scheiben schneiden, mit dem Sofrito belegen und einrollen. In einer Pfanne Olivenöl erhitzen und die eingerollten Filets 5 Minuten anbraten. Abkühlen lassen, in 4 gleich große Zylinder schneiden und auf einem Teller anrichteten. Die Lotuswurzel schälen, in Scheiben schneiden und in einem Topf mit Salzwasser 20 Minuten weich kochen. Eine Mischung aus Wasser, Essig, Salz und Zucker, 6 Korianderzweigen und 1 Chili zubereiten. Den Lotus abgießen und in diese Marinade geben.
Die Fleischzylinder mit der Sauce begießen und mit der Möhre, dem Chayote und dem Daikon in Julienne dekorieren.

150 g d'entrecôte de bœuf
1/2 oignon
1 piment rouge
1 tomate
2 gousses d'ail
2 c. à soupe d'huile d'olive
1 racine de lotus
250 ml d'eau
100 ml de vinaigre de vin blanc
25 g de sucre
6 branches de coriandre
1 pointe de piment chili haché
Sel
50 g de garniture : carotte, chayotte et daikon
(radis blanc) en julienne

Hacher 1/2 oignon, 1 piment rouge, 1 tomate et 2 gousses d'ail et les faire revenir à la poêle dans de l'huile pendant 5 minutes. Couper l'entrecôte en très fines tranches, déposer un peu de sofrito sur chacune d'elle et rouler. Faire chauffer de l'huile dans une poêle, y faire revenir les rouleaux de viande pendant 5 minutes. Laisser refroidir, couper en 4 cylindres égaux, les enfiler sur une brochette et les disposer sur une assiette. Éplucher le lotus, le couper en rondelles et le faire bouillir dans une casserole d'eau salée 20 minutes. Mélanger un peu d'eau, vinaigre, sel, sucre, 6 branches de coriandre et le chili puis y tremper le lotus.
Arroser la viande de sauce et garnir de carotte, chayotte et daikon coupés en julienne.

150 g di entrecôte
1/2 cipolla
1 peperone rosso
1 pomodoro
2 spicchi d'aglio
2 cucchiai d'olio d'oliva
1 radice di loto
250 ml d'acqua
100 ml di aceto di vino bianco
25 g di zucchero
6 rametti di coriandolo
1 peperoncino piccante tritato
Sale
50 g di contorno: carota, chayote e daikon
(ravanello bianco) a julienne

Tagliare 1/2 cipolla, 1 peperone rosso, 1 pomodoro e 2 spicchi d'aglio e soffriggere in una padella con olio per 5 minuti. Tagliare l'entrecôte a filetti molto fini, collocare all'estremità di ognuno un poco di soffritto e arrotolare. Scaldare in una padella alcune gocce d'olio e rosolare a fuoco vivo per 5 minuti, lasciar raffreddare, tagliare ogni filetto arrotolato in 4 cilindri della stessa dimensione e disporli su un piatto. Pelare il loto, tagliarlo a rondelle e lessarlo in una pentola con acqua salata per 20 minuti. Preparare una soluzione di acqua, aceto, sale, zucchero, 6 rametti di coriandolo e 1 peperoncino piccante e immergere il loto in questa marinata.
Cospargere i cilindri di carne di salsa di loto e decorare con la carota, il chayote e il daikon tagliati a julienne.

Refectori

Architect: Rafel Balaguer Galmés, Rafel Balaguer Prunés
Chef: Manuel Molina

c/ de la Missió, 7 A I 07003 Palma de Mallorca, Mallorca
Phone: +34 971 227 347
www.conventdelamissio.com
Opening hours: Mon–Fri 1 pm to 3:30 pm, 8 pm to 10:30 pm,
Sat 8 pm to 10:30 pm
Average menu price: € 80
Cuisine: Creative
Special features: The restaurant of the Convent de la Missió Hotel opens to public
for lunches and dinners

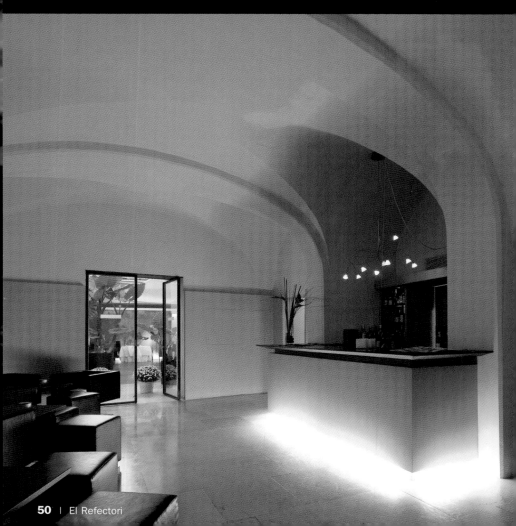

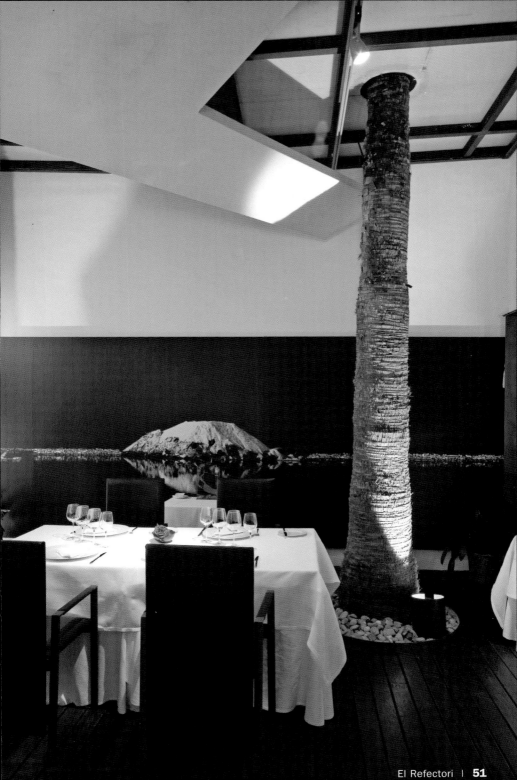

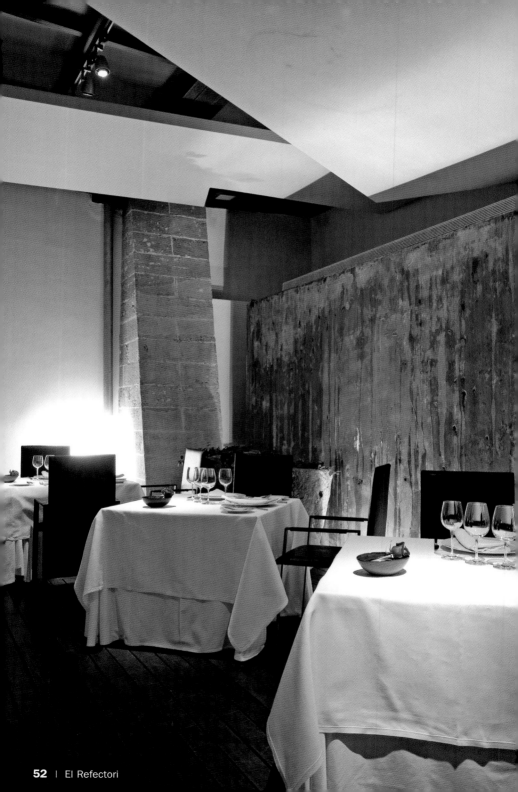

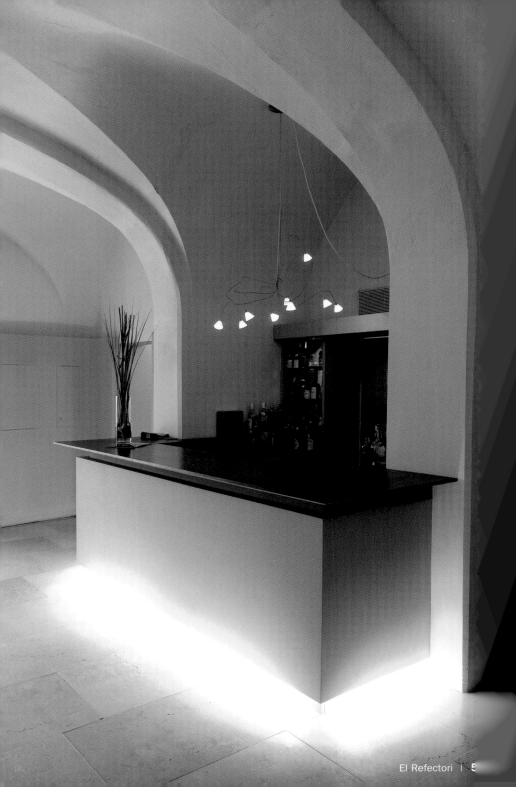

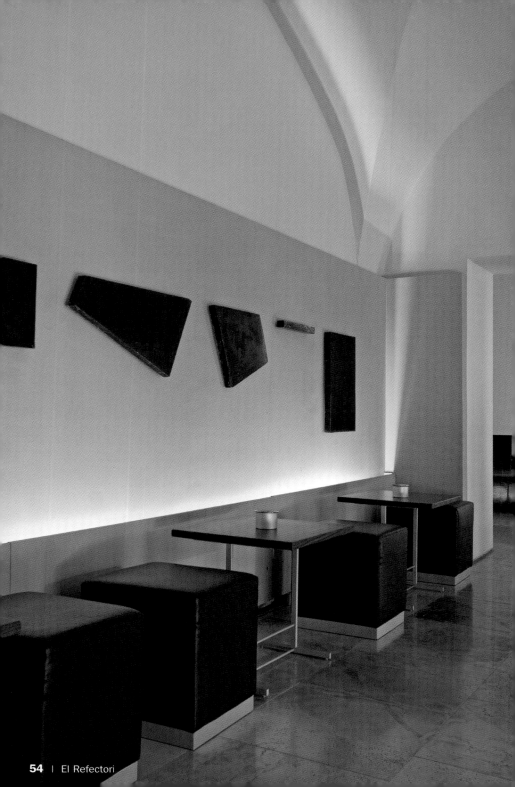

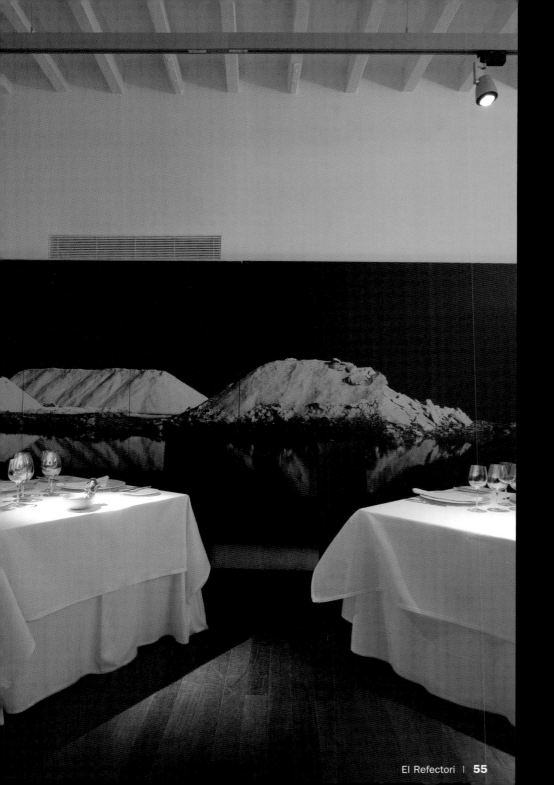

Restaurant 365

Architect: Ignasi Forteza | Chef: Joan Marc Garcies

Son Brull Hotel, Ctra. Palma-Pollença PM 220, km 49,8
07460 Pollença, Mallorca
Phone: +34 971 535 353
www.sonbrull.com
Opening hours: Mon–Sun 8 pm to 10:30 pm
Average price: € 43
Cuisine: Creative Majorcan cuisine, author cuisine
Special features: The revival of Majorcan cuisine is reflected in dishes based on local recipes, old and new

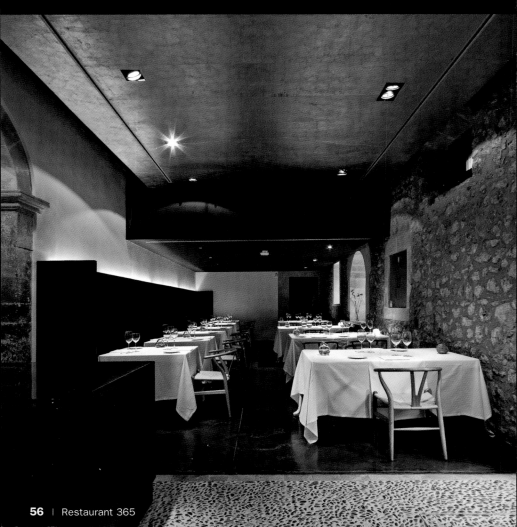

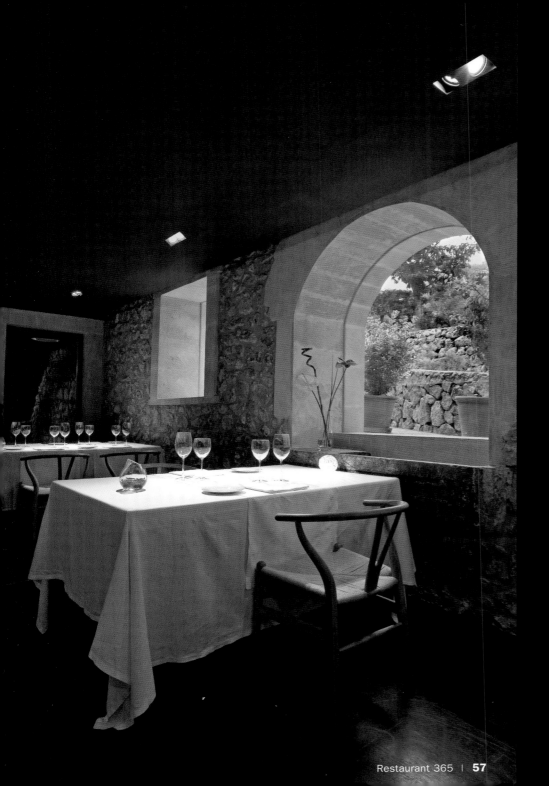

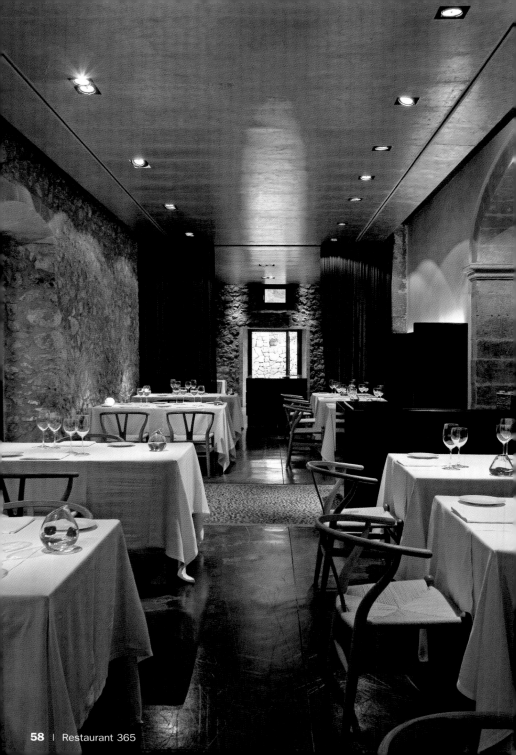

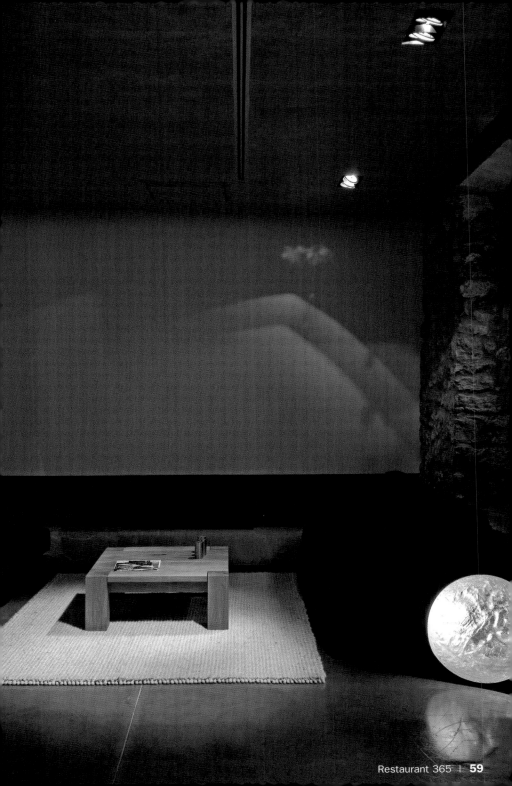

Pichón

con puré de castañas

Pigeon with Chestnut Purée
Junge Taube mit Kastanienpüree
Pigeonneau à la purée de marrons
Piccione con purè di castagne

Pechuga y muslos de 1 pichón
100 g de castañas
1/2 puerro
200 g de membrillo cortado en tiras
30 g de azúcar
1 cucharada de zumo de limón
50 ml de agua
20 ml de aceite de oliva
10 g de pistachos
200 ml de caldo de carne
25 g de chocolate picado
Sal

Asar las castañas, pelarlas y machacarlas con un tenedor. Añadir el puerro, cubrir con agua y hervir durante 5 minutos. Pasar por un pasapu-rés, rectificar de sal y reservar. Sumergir el membrillo en una solución de agua, 15 g de azú-car y limón. Glasear en el horno hasta que ca-ramelice. Marcar los muslos y la pechuga del pi-chón en una sartén con aceite. Hornear durante 5 minutos y dejar entibiar. Rociar los pistachos con 15 g de azúcar, triturarlos y esparcirlos so-bre la pechuga y los muslos del pichón. Gratinar durante 20 minutos. Preparar una salsa mez-clando el caldo previamente calentado con el chocolate.
Disponer en el fondo del plato la salsa de cho-colate y el puré de castañas. Agregar la pechu-ga y los muslos del pichón y decorar con el membrillo.

Breast and thighs of 1 pigeon
3 1/2 oz raw chestnuts
1/2 leek
7 oz quince cut in strips
1 oz sugar
1 tbsp lemon juice
50 ml water
20 ml olive oil
1/3 oz pistachio
200 ml meat stock
7/8 oz chopped chocolate
Salt

Roast, peel and grind the chestnuts with a fork. Add the leek, cover with water and boil for 5 min-utes. Mash, add salt and set aside. Submerge the quince in a solution of water, 1/2 oz of sugar and lemon juice. Glaze inside the oven until caramelized. Sear the pigeon thighs and breast in a pan with oil. Roast in the oven for 5 minutes and leave to cool. Grind the pistachio with 1/2 oz of sugar and sprinkle over the pigeon breast and thighs. Brown for 20 minutes. Prepare a sauce by mixing the previously heated stock with the chocolate.
Cover the bottom of the plate with the chocolate sauce and chestnut purée. Add the pigeon breast and thighs and decorate with the quince.

Keulen und Brust von 1 Taube
100 g rohe Esskastanien
1/2 Lauch
200 g Quitte, in Streifen geschnitten
30 g Zucker
1 EL Zitronensaft
50 ml Wasser
20 ml Olivenöl
10 g Pistazien
200 ml Fleischbrühe
25 g gehackte Schokolade
Salz

Die Esskastanien im Ofen backen, schälen und mit einer Gabel zerdrücken. Den Lauch hinzugeben und mit Wasser bedeckt 5 Minuten lang ko-

chen. Pürieren, salzen und zur Seite stellen. Die Quitten mit 15 g Zucker, Zitrone und Wasser im Ofen glasieren bis sie karamellisiert sind. Die Taubenkeulen und die Brust in einer Pfanne mit Olivenöl anbraten. Danach 5 Minuten im Ofen backen und abkühlen lassen. Die Pistazien mit 15 g Zucker zermahlen und auf die Taubenbrust und Keulen streuen. 20 Minuten lang gratinieren. Für die Sauce die Fleischbrühe erhitzen und mit der Schokoladenkuvertüre mischen. Zuerst die Schokoladensauce und das Kastanienpüree auf einen Teller geben, danach Taubenbrust und Keulen hinzufügen. Mit Quittenstäbchen dekorieren.

Cuisses et blancs de 1 pigeon
100 g de marrons
1/2 poireau
200 g de coing en quartiers
30 g de sucre
1 c. à soupe de jus de citron
50 ml d'eau
20 ml d'huile d'olive
10 g de pistaches
200 ml de bouillon de viande
25 g de couverture de chocolat haché
Sel

Cuire les marrons au four, les éplucher et les écraser à la fourchette. Ajouter le poireau, couvrir d'eau et faire bouillir 5 minutes. Passer au

presse-purée, saler et réserver. Plonger les quartiers de coing dans un peu d'eau avec 15 g de sucre et le citron. Glacer au four jusqu'à caramélisation. Faire revenir dans l'huile à la poele les cuisses et le blanc du pigeon. Mettre au four pendant 5 minutes et laisser refroidir. Ecraser les pistaches et 15 g de sucre, mélanger et en saupoudrer les pièces de pigeon. Gratiner pendant 20 minutes. Préparer une sauce avec le bouillon de viande et le chocolat.
Disposer sur une assiette un fond de sauce au chocolat et la purée de marron. Ajouter le blanc et les cuisses de pigeon et décorer avec le coing confit.

Petto e cosce di 1 piccione
100 g di castagne
1/2 porro
200 g di mele cotogne tagliate a strisce
30 g di zucchero
1 cucchiaio di succo di limone
50 ml d'acqua
20 ml d'olio d'oliva
10 g di pistacchi
200 ml di brodo di carne
25 g di cioccolato a scaglie
Sale

Cuocere le castagne al forno, pelarle e schiacciarle con una forchetta. Aggiungere il porro, coprire con acqua e far bollire per 5 minuti. Pas-

sare al passatutto, correggere di sale e mettere da parte. Immergere le mele cotogne in una soluzione d'acqua, 15 g di zucchero e limone. Glassare al forno fino a far caramellare le mele. Scottare le cosce e il petto del piccione in una padella con un po' d'olio. Infornarle per 5 minuti e lasciarle raffreddare. Spolverare i pistacchi con 15 g di zucchero, tritarli e cospargervi il petto e le cosce del piccione. Gratinare per 20 minuti. Preparare una salsa mescolando il brodo precedentemente riscaldato assieme al cioccolato.
Sistemare sul fondo del piatto la salsa di cioccolato e il purè di castagne. Aggiungere il petto e le cosce di piccione e decorare con i pezzetti di mele cotogne.

Sa Torre de Santa Eugenia

Architect: Victoriano López-Pinto, M.ª Teresa Ivars
Chef: Victoriano López-Pinto, Carme Jubany Soldevila

Alqueries, 70 | 07142 Santa Eugenia, Mallorca
Phone: +34 971 144 011
www.sa-torre.com
Opening hours: Tue–Sun 1 pm to 3 pm, 8 pm to 10:30 pm
Average price: € 35
Cuisine: Creative cuisine
Special features: Located in an old wine cellar, the immenseness of the space
combines with the warmth and elegance of the decor

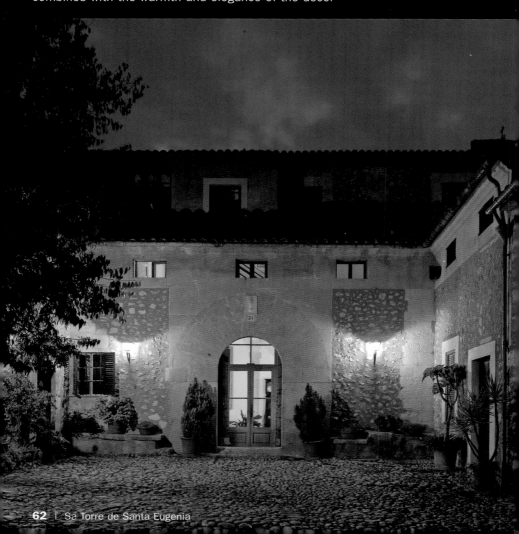

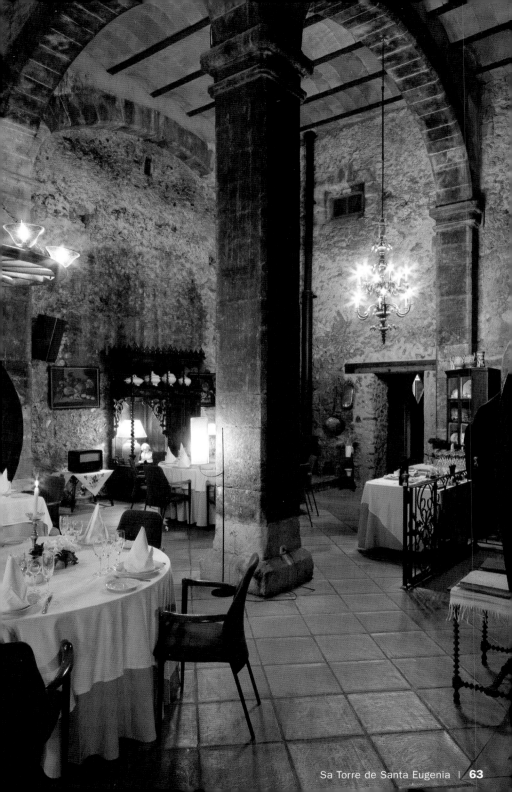

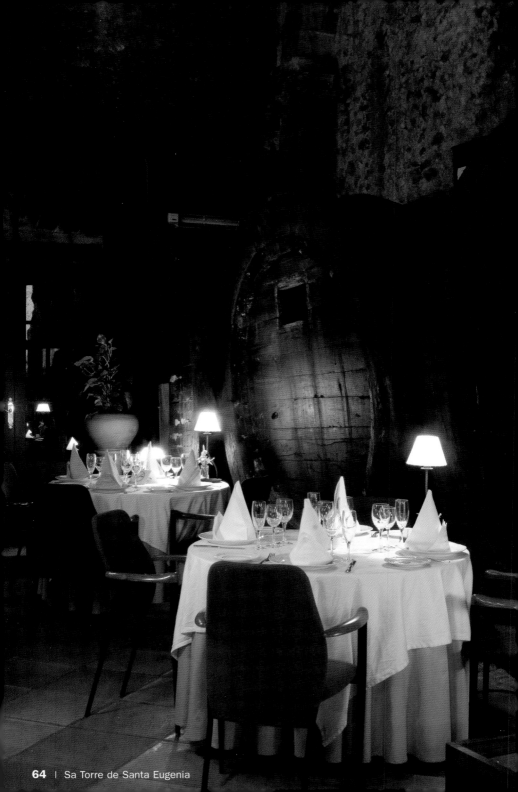

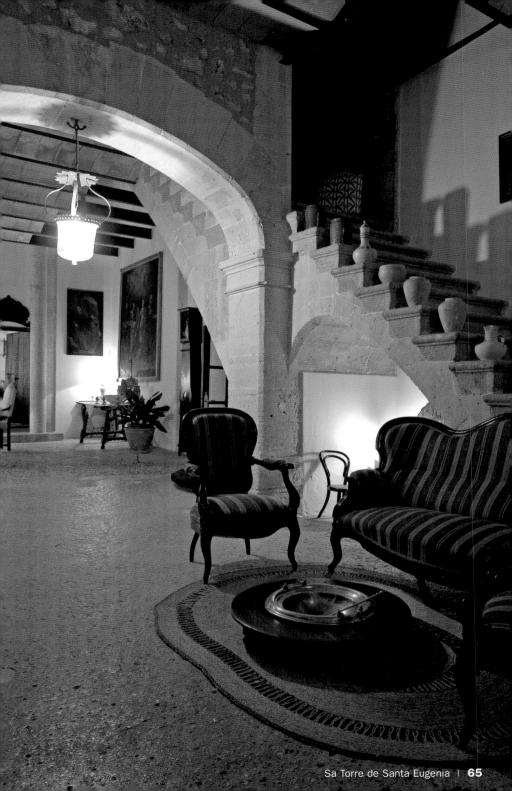

Costillas de cordero

con verduras

Lamb cutlets with Vegetables
Lammkoteletts mit gedünstetem Gemüse
Côtes d'agneau aux légumes sautés
Costolette di agnello con verdure

10 costillas de cordero
500 ml de agua
200 g de hielo
12 espárragos trigueros
15 tomates cherry
4 cebollas
50 ml de aceite de oliva
500 ml de jerez Pedro Ximénez
150 g de azúcar
500 g de higos
Sal y pimienta

Marcar en la plancha las costillas de cordero. Hervir los espárragos verdes durante 10 minutos y cortar la cocción sumergiéndolos en un recipiente con agua y hielo. Escaldar las cebollas y los tomates cherry, saltearlos en una sartén con aceite durante 5 minutos y salpimentar. Hornear las costillas a 180 °C durante 15 minutos, cuidando que la carne quede rosada y jugosa. En una cazuela, calentar durante 5 minutos la mezcla de Pedro Ximénez y el azúcar. Disponer las costillas en el centro del plato. Coronar con los higos cortados por la mitad y los tomates cherry pelados, y disponer en el centro los espárragos. Rociar con la reducción de Pedro Ximénez.

10 lamb cutlets
500 ml water
7 oz ice
12 green asparagus
15 cherry tomatoes
4 onions
50 ml olive oil
500 ml Pedro Ximénez sherry
5 1/4 oz sugar
1 lb 1 3/4 oz fresh figs
Salt and pepper

Barbecue the lamb cutlets on the grill. Boil the green asparagus for 10 minutes, then place them in a bowl with cold water and ice. Scald the onions and cherry tomatoes and lightly fry all vegetables with a splash of olive oil for 5 minutes. Add salt and pepper. Roast the meat at 360 °F for 15 minutes in the oven, making sure the meat is pink and juicy. In a pot, heat the Pedro Ximénez with the sugar for 5 minutes. Position the cutlets in the center of the plate and top with split figs and peeled cherry tomatoes, placing the asparagus in the center. Cover with the reduced Pedro Ximenez.

10 Lammkoteletts
500 ml Wasser
200 g Eiswürfel
12 grüne Spargel
15 Cherrytomaten
4 Zwiebeln
50 ml Olivenöl
500 ml Sherry Pedro Ximénez
150 g Zucker
500 g Feigen
Salz und Pfeffer

Die Lammkoteletts auf dem Grill braten. Den grünen Spargel 10 Minuten kochen und in einem Topf mit Wasser und Eis abschrecken. Die Cherrytomaten und die Zwiebeln im gleichen Kochwasser blanchieren und schälen. Das gesamte Gemüse in einer Pfanne mit etwas Öl, Salz und Pfeffer 5 Minuten anschmoren. Die Lammkoteletts im Ofen 15 Minuten lang bei 180 °C backen. Das Fleisch sollte rosa und saftig sein. Den Pedro Ximénez und Zucker in einen Topf geben und 5 Minuten lang erhitzen. Die Lammkoteletts in die Mitte des Tellers legen. Die halbierten Feigen und Cherrytomaten um die Koteletts anordnen und mit dem Spargel dekorieren. Mit dem reduzierten Sherry übergießen.

10 côtes d'agneau
500 ml d'eau
200 g de glaçons
12 asperges vertes
15 tomates cerise
4 oignons
50 ml d'huile d'olive
500 ml de sherry Pedro Ximénez
150 g de sucre
500 g de figues
Sel et poivre

Faire griller la viande dans un peu d'huile d'olive. Faire bouillir les asperges vertes 10 minutes, les retirer à mi-cuisson et les rafraîchir dans un récipient d'eau froide avec glaçons. Blanchir les tomates cerise et les oignons, les éplucher et les faire sauter dans une poêle avec un peu d'huile, sel et poivre 5 minutes. Enfourner les côtes à 180 °C 15 minutes. Vérifier que la viande reste rose et juteuse. Dans une casserole, faire chauffer jusqu'à obtenir un caramel doux le sherry Pedro Ximénez et le sucre pendant 5 minutes.
Disposer les côtes au centre de l'assiette. Disposer autour, les demi-figues et les tomates cerise et, au centre, les asperges. Arroser de réduction au sherry Pedro Ximénez.

10 costolette d'agnello
500 ml d'acqua
200 g di ghiaccio
12 asparagi verdi
15 pomodori cherry
4 cipolle
50 ml d'olio d'oliva
500 ml di sherry Pedro Ximénez
150 g di zucchero
500 g di fichi
Sale e pepe

Scottare sulla piastra le costolette d'agnello. Far bollire gli asparagi verdi per 10 minuti, poi interrompere il bollore immergendoli in un recipiente con acqua e ghiaccio. Sbollentare le cipolle e i pomodori cherry e pelarli, saltare tutta la verdura in una padella con un po' d'olio per 5 minuti, salare e pepare. Mettere le costolette in forno a 180 °C per 15 minuti facendo attenzione a far rimanere la carne rosata e succosa. In una pentola scaldare per 5 minuti lo sherry Pedro Ximénez con lo zucchero.
Disporre le costolette al centro del piatto. Tutto attorno sistemarvi i fichi tagliati a metà e i pomodori cherry, e in mezzo porre gli asparagi. Cospargere con la riduzione di Pedro Ximénez.

Senzone

Architect: Hospes Design | Chef: Juan Portillo

Ctra. d'Andratx 11 | 07184 Calvià, Mallorca
Phone: +34 971 707 744
www.hospes.es
Opening hours: Mon–Sun, breakfast 8 am to 11 am, lunch 1 pm to 3 pm, dinner
8 pm to 10:30 pm
Average price: € 45
Cuisine: Mediterranean
Special features: Terrace overlooking the sea. Speciality: lobster broth

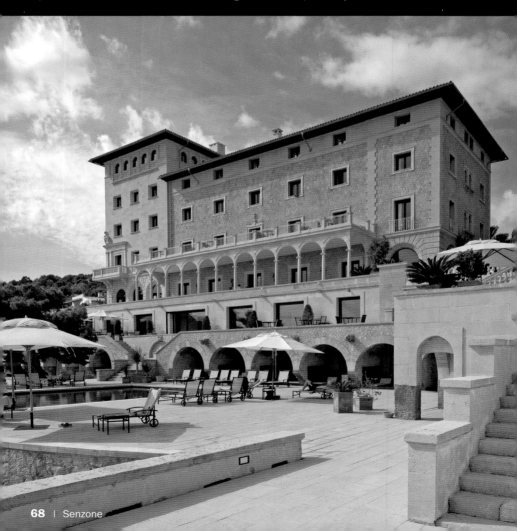

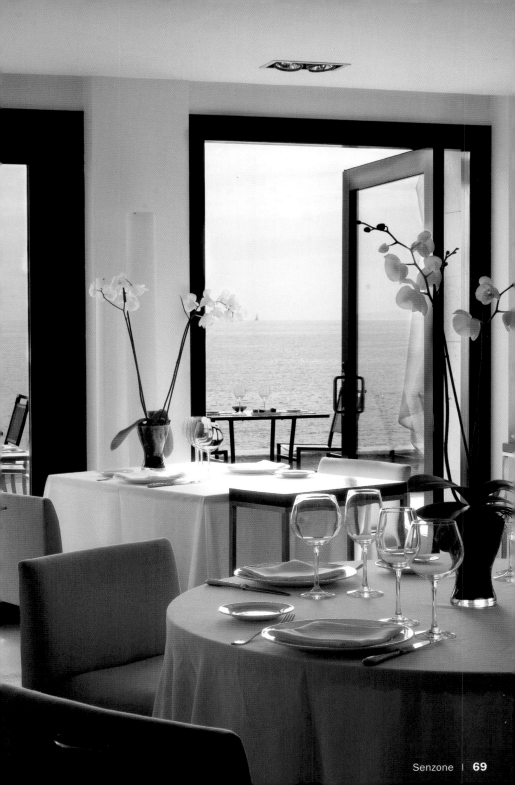

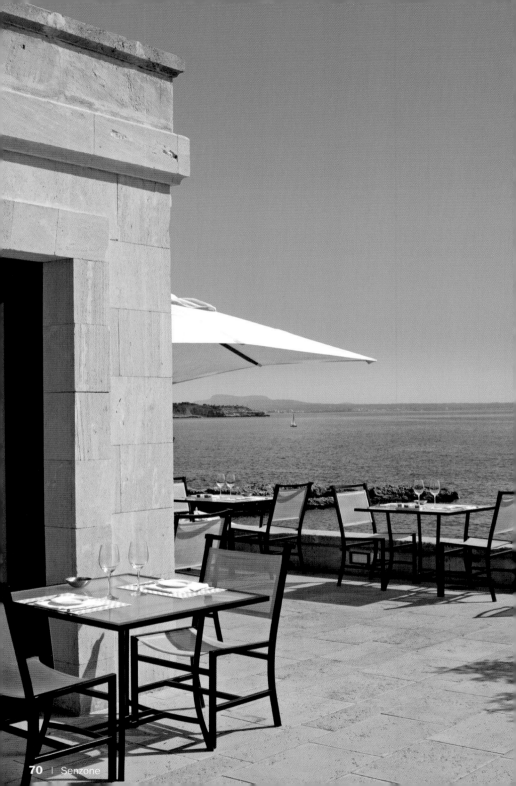

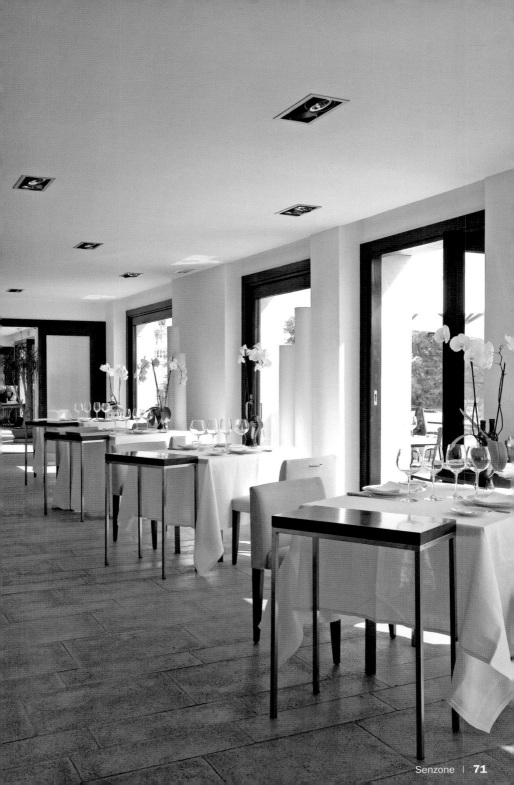

Lechón

con relleno de mousse

Suckling Pig with Mousse Stuffing
Spanferkel mit Mousse gefüllt
Cochon de lait farci à la mousse de mérou
Maialino da latte con ripieno di mousse

6 costillas de lechón
200 g de mero
100 ml de caldo de verduras
2 yemas de huevo
200 ml de nata
1 ramita de tomillo
200 g de sobrasada
1 morcilla blanca
1 cucharada de miel
Sal y pimienta

Hervir el mero en el caldo de verduras durante 1/2 hora, trocearlo y pasarlo por la licuadora. Añadir las yemas de huevo y la nata, removiendo hasta obtener una mousse homogénea. Sal-pimentar y agregar el tomillo. Aplanar la sobrasada entre 2 láminas de film transparente con la ayuda de un rodillo y endurecerla en el congelador durante 1 hora. Retirar luego el film y cortarla en cuadrados de 10 cm de lado. Laminar la morcilla y secarla en el horno a 80 °C durante 5 minutos. Deshuesar las costillas, rellenarlas con la mousse y envolverlas en papel de aluminio. Hornear durante 1/2 hora a 160 °C. Retirar el papel y cortar en trozos.
Disponer en el plato un cuadrado de sobrasada pintada con miel, un trozo de carne y unas lonchas de morcilla.

6 ribs of suckling pig
7 oz grouper
100 ml vegetable stock
2 egg yolks
200 ml single cream
1 sprig of thyme
7 oz sobrasada (spicy red sausage pate)
1 white morcilla (Spanish sausage)
1 tbsp of honey
Salt and pepper

Boil the grouper in vegetable stock for 1/2 an hour, cut and mix in a blender. Add the egg yolks and the cream until achieving a smooth cream. Add salt, pepper and thyme. Flatten the sobrasada with a rolling pin between two 2 sheets of cling wrap and leave to harden in the freezer for 1 hour. Remove the cling wrap and cut it into 4 inch squares. Finely slice the morcilla and dry in the oven at 175 °F for 5 minutes. Remove the bones and cartilage from the pork, stuff with the grouper mousse and wrap in aluminum foil. Cook in the oven at 320 °F for 1/2 an hour. Remove the aluminum foil and cut into pieces.
Place a square layer of sobrasada brushed with honey on the bottom of the dish. Arrange the pork and the slices of morcilla.

6 Rippen vom Spanferkel
200 g Zackenbarsch
100 ml Gemüsebrühe
2 Eigelb
200 ml Sahne
1 Thymianzweig
200 g Sobrasada (Paprikastreichwurst)
1 Morcilla blanca (weiße spanische Blutwurst)
1 EL Honig
Salz und Pfeffer

Den Zackenbarsch in der Gemüsebrühe eine 1/2 Stunde kochen, zerkleinern und durch den Entsafter geben. Die Eigelbe und die Sahne einrühren bis eine gleichmäßige Creme entsteht.

Salzen, Pfeffern und den Thymian hinzugeben. Die Sobrasada zwischen 2 Stücken Plastikfolie mit dem Nudelholz glatt rollen und im Tiefkühlfach 1 Stunde lang hart werden lassen. Die Plastikfolie entfernen und in 10 cm große Quadrate schneiden. Die Morcilla in feine Scheiben schneiden und im Backofen 5 Minuten lang bei 80 °C trocknen lassen. Das Spanferkel entbeinen, mit der Zackenbarsch-Mousse füllen und in Alufolie wickeln. Im Ofen bei 160 °C 1/2 Stunden lang backen lassen. Die Alufolie entfernen und Stücke schneiden.
Auf einem Teller ein, mit Honig bepinseltes, Sobrasada-Quadrat, die Spanferkelstücke und die Morcilla Scheiben anrichten.

6 côtes de cochon de lait
200 g de mérou
100 ml de bouillon de légumes
2 jaunes d'œuf
200 ml de crème fraîche
1 brindille de thym
200 g de « sobrasada » (charcuterie majorquine)
1 « morcilla blanca » (boudin blanc)
1 c. à soupe de miel
Sel et poivre

Faire bouillir le mérou dans le bouillon de légumes 1/2 heure, le couper en petits morceaux et passer au mixeur. Ajouter les jaunes d'œuf et la crème jusqu'à obtention d'une mousse homo-

gène. Saler, poivrer et ajouter le thym. Aplatir au rauteau la « sobrasada » entre 2 feuilles de film plastique et mettre au congélateur 1 heure. Retirer le plastique et la couper ensuite en carrés de 10 cm. Couper le boudin en fines lamelles et les sécher 5 minutes au four à 80 °C. Réserver. Désasser le cochon de lait, le farcir de mousse de mérou et l'evelopper dans une feuille d'aluminium. Cuire au four 1/2 heure à 160 °C. Retirer l'aluminium et couper.
Au fond de l'assiette, déposer un carré de « sobrasada » enduite de miel, un morceaux de viande et les tranches de boudin.

6 costine di maialino da latte
200 g di cernia
100 ml di brodo di verdure
2 tuorli d'uovo
200 ml di panna
1 rametto di timo
200 g di sobrasada (soppressata)
1 morcilla bianca (sanguinaccio bianco spagnolo)
1 cucchiaio di miele
Sale e pepe

Bollire la cernia nel brodo di verdure per 1/2 ora, spezzettarla e passarla nel tritatutto. Aggiungere i tuorli d'uovo e la panna e mescolare fino ad ottenere una mousse omogenea.

Salare, pepare e aggiungere il timo. Spianare la sobrasada tra 2 fogli di pellicola trasparente con l'aiuto di un matterello e farla indurire nel congelatore per 1 ora. Togliere la pellicola e tagliarla a quadrati di 10 cm di lato. Tagliare il sanguinaccio a fettine e farle seccare nel forno a 80 °C per 5 minuti. Disossare le costine, farcirle con la mousse e avvolgerle con un foglio di alluminio. Cuocere per 1/2 ora a 160 °C. Togliere l'alluminio e tagliare a pezzetti.
Disporre su un piatto un quadrato di sobrasada spennellata con il miele, un pezzetto di carne e alcune fettine di sanguinaccio.

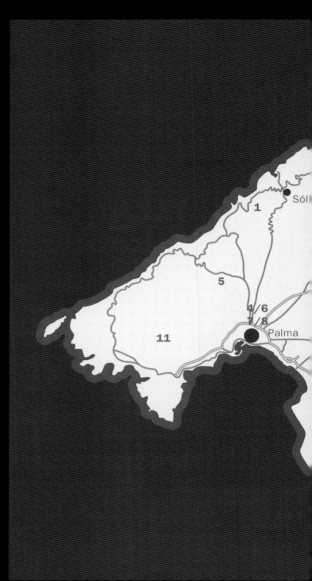

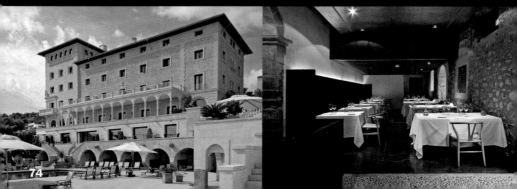

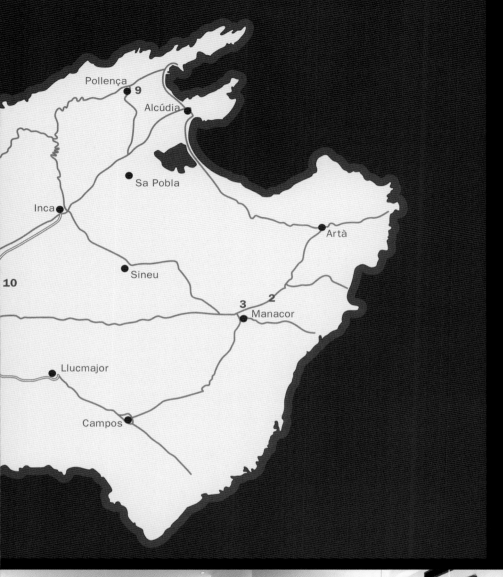

Pollença
9
Alcúdia
Sa Pobla
Inca
Artà
Sineu
10
3 2
Manacor
Llucmajor
Campos

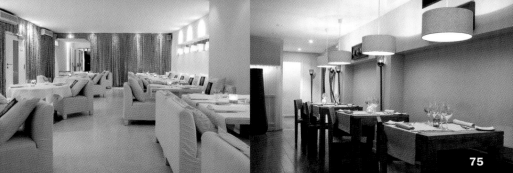

Aura

Architect: Hayden Trethewy | Chef: Damian Coutts

Ctra. Sant Joan, km 13,5 | Ibiza
Phone: +34 971 325 356
Opening hours: Summer Mon–Sun 8 pm to 3 am, winter Mon–Sat 1 pm to 5 pm,
8 pm to 3 am, Sun 1 pm to 1 am
Average price: Dinner € 30 menu € 9.50
Cuisine: Mediterranean and international
Special features: Menu of the day, Sunday brunch menu, art gallery, poolroom, DJs

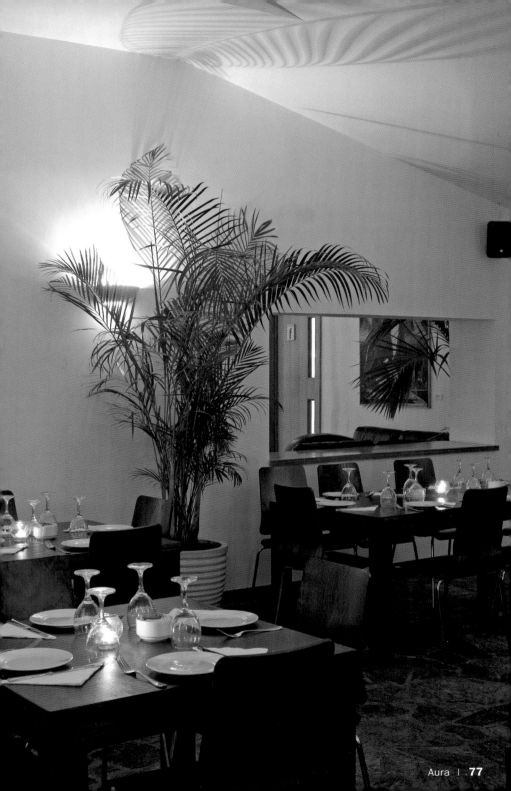

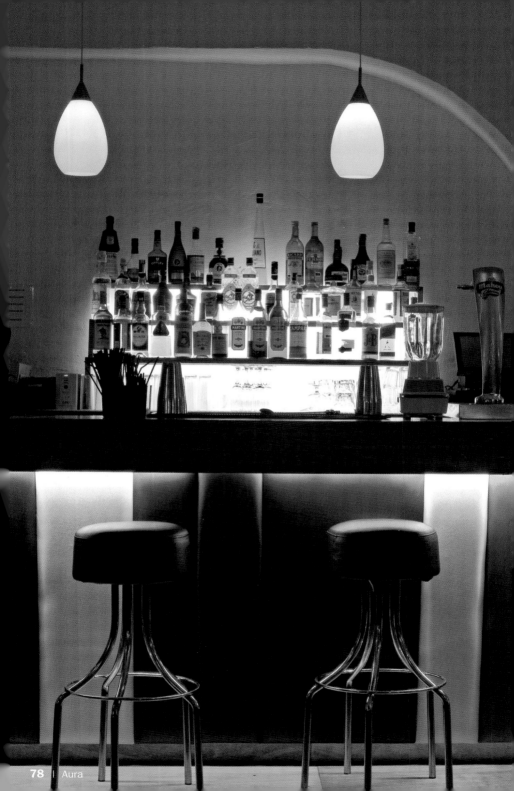

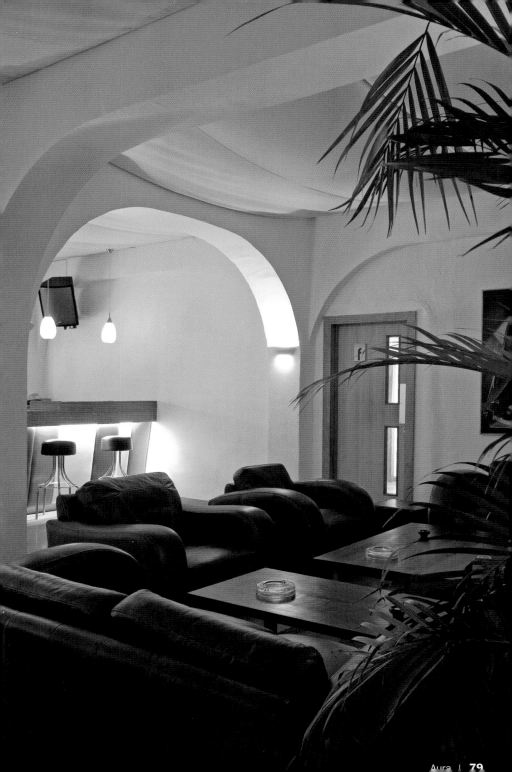

Solomillo de cerdo

con salsa Tom Yum

Pork Sirloin with Tom Yum Sauce

Schweinelende mit Tom-Yum-Sauce

Filet mignon de porc avec sauce Tom Yum

Arista di maiale con salsa Tom Yum

500 g de solomillo de cerdo
2 pimientos rojos
2 cebollas
4 huevos
250 ml de leche
200 g de pan rallado
3 cucharadas de aceite de oliva
2 cucharadas de pasta Tom Yum
8 hojas de lima
10 ramitas frescas de hierba de limón
2 g de jengibre fresco picado
2 dientes de ajo picados
400 ml de leche de coco
2 manojos de berro
Sal

Trocear los pimientos y la cebolla y hervir en agua con sal hasta que se reblandezcan. Retirarlos del fuego y depositarlos en un recipiente con agua helada. Filetear el solomillo de cerdo. Batir los huevos y la leche en un mismo recipiente y rebozar el solomillo primero en esta mezcla y después en el pan rallado. Dorarlo en una sartén con un poco de aceite. Para preparar la salsa, freír la pasta, las hojas de lima, la hierba de limón, el jengibre y los ajos hasta que la mezcla se dore. Añadir la leche de coco y llevarlo todo a ebullición. Cocer a fuego lento durante 45 minutos y colarlo.
Disponer en un plato un lecho de pimientos y cebolla. Coronar con el solomillo empanado y decorar con el berro. Regar con la salsa y servir caliente.

1 lb 1 1/2 oz pork sirloin
2 red peppers
2 onions
4 eggs
250 ml milk
7 oz breadcrumbs
3 tbsp olive oil
2 tbsp Tom Yum paste
8 lime leaves
10 sprigs fresh lemon herb
2/25 oz finely chopped fresh ginger
2 chopped garlic cloves
400 ml coconut milk
2 bundles watercress
Salt

Chop the peppers and onions and boil in salt water until soft. Remove from heat and place in a bowl of freezing water. Filet the pork. Beat the eggs and the milk together in a bowl, dip the meat and coat with breadcrumbs. Fry in a pan with a bit of oil until golden. To prepare the sauce, fry the paste, lime leaves, lemon herb, ginger and garlic until the mix goldens. Add the coconut milk and bring to a boil. Simmer on low heat for 45 minutes and strain.
Prepare a base with the peppers and onions and crown with the breaded sirloin. Decorate with the watercress, dress with the sauce and serve hot.

500 g Schweinelende
2 rote Paprika
2 Zwiebeln
4 Eier
250 ml Milch
200 g Paniermehl
3 EL Olivenöl
2 EL Tom-Yum-Paste
8 Limettenblätter
10 Stengel frisches Zitronengras
2 g frischer, gehackter Ingwer
2 gehackte Knoblauchzehen
400 ml Kokosmilch
2 Bund Brunnenkresse
Salz

Paprika und Zwiebeln in Stücke schneiden und in Salzwasser weich kochen. Vom Feuer nehmen und in eine Schale mit Eiswasser geben. Das Schweinelendenstück filetieren. Anschließend Eier und Milch im gleichen Gefäß schlagen. Die Lendenstückchen zuerst in dieser Mischung und dann in Paniermehl panieren und in einer Pfanne mit etwas Öl goldbraun braten. Für die Sauce: die Paste, die Limettenblätter, das Zitronengras, den Ingwer und den Knoblauch goldbraun anbraten. Die Kokosmilch dazugeben und zum Kochen bringen. Auf kleiner Flamme 45 Minuten lang kochen und dann abseihen.
Die Paprika und die Zwiebeln auf einem Teller anrichten. Darüber die panierten Schweinelendenstücke geben und mit der Brunnenkresse dekorieren. Mit der Sauce übergießen und heiß servieren.

500 g de filet mignon de porc
2 poivrons rouges
2 oignons
4 œufs
250 ml de lait
200 g de chapelure
3 c. à soupe d'huile d'olive
2 c. à soupe de pâte Tom Yum
8 feuilles de limette
10 brins frais de citronnelle
2 g de gingembre frais émincé
2 gousses d'ail émincées
400 ml de lait de coco
2 bottes de cresson
Sel

Émincer les poivrons et l'oignon et les faire blanchir dans l'eau salée. Les retirer du feu et les déposer dans un récipient d'eau glacée. Fileter le porc. Fouetter les œufs et le lait ensemble dans un récipient, y tremper le filet de porc puis le paner dans la chapelure et le faire revenir dans une poêle avec un peu d'huile jusqu'à ce qu'il soit doré. Pour préparer la sauce, frire et faire dorer la pâte, les feuilles de limette, la citronnelle, le gingembre et les gousses d'ail. Ajouter le lait de coco et porter à ébullition. Cuire à feu réduit pendant 45 minutes et passer au chinois.
Disposer sur une assiette un peu des poivrons et d'oignon. Couronner de filet mignon de porc et décorer de cresson. Arroser de sauce et servir chaud.

500 g di arista di maiale
2 peperoni rossi
2 cipolle
4 uova
250 ml di latte
200 g di pan grattato
3 cucchiai d'olio d'oliva
2 cucchiai di pasta Tom Yum
8 foglie di limetta
10 rametti freschi di erba cedrina
2 g di zenzero fresco tritato
2 spicchi d'aglio tritati
400 ml di latte di cocco
2 mazzetti di crescione
Sale

Tagliare a pezzetti i peperoni e la cipolla e bollirli in acqua salata finché non diventano teneri. Toglierli dal fuoco e versarli in un recipiente con acqua ghiacciata. Tagliare l'arista a filetti. Quindi sbattere le uova e il latte in uno stesso recipiente, bagnarvi l'arista, poi impanarla con il pan grattato. Friggere i filetti in una padella con un po' d'olio fino a farli dorare. Per preparare la salsa, friggere la pasta, le foglie di limetta, l'erba cedrina, lo zenzero e gli spicchi d'aglio fino a cha avranno acquisito una bella doratura. Aggiungere il latte di cocco e portare il tutto ad ebollizione. Cuocere a fuoco lento per 45 minuti, dopodiché filtrarlo.
Adagiare sul fondo di un piatto un letto di rucola e cipolla. Disporvi sopra l'arista impanata e decorare con il crescione. Cospargere di salsa e servire caldo.

Banyan Palace

Architect: Allen York | Chef: Vichitpong Kaomai

Avda. San Agustín, 73 | 07820 Port des Torrent, Ibiza
Phone: +34 971 347 735
www.banyan-palace.com
Opening hours: Summer Mon–Sun 8 pm to 3 am, winter Mon–Sun 7 pm to 2 am
Average price: € 30
Cuisine: Thai
Special features: An insight into Thai culture... in Spain

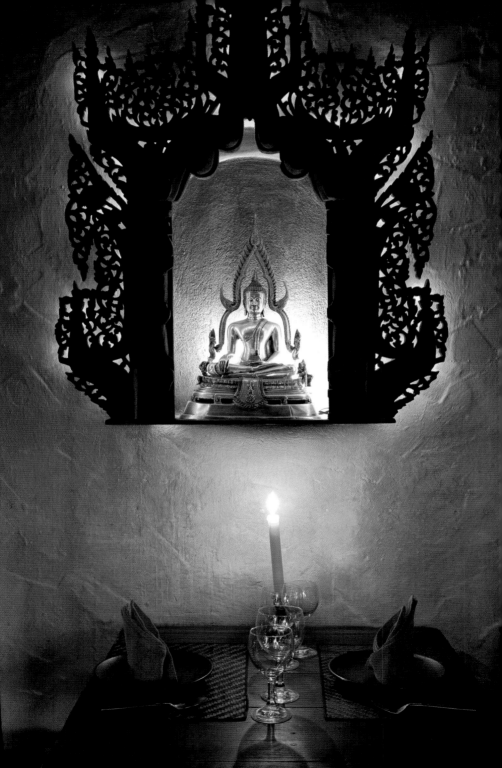

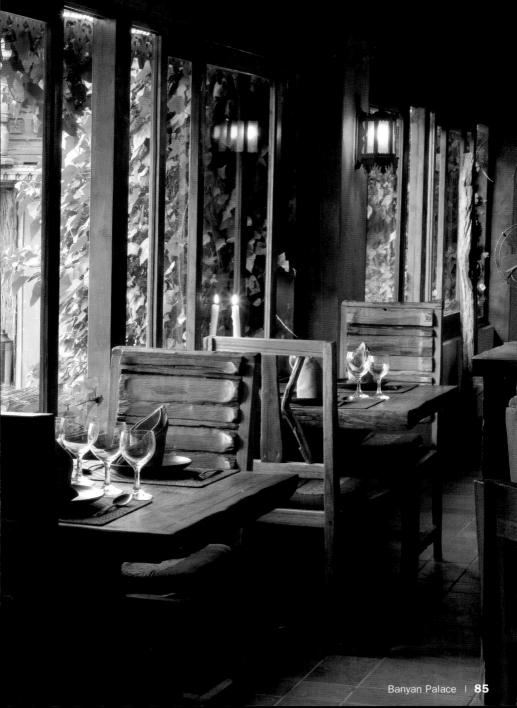

Crema

de pollo y coco

Cream of chicken and coconut
Huhn- und Kokosnuss-Creme
Crème de poulet et noix de coco
Crema di pollo e cocco

250 ml de leche de coco
150 ml de caldo de pollo
4 limones
250 g de pechuga de pollo
4 limas
20 ml de zumo de limón
20 ml de caldo de pescado
40 g de azúcar
8 chiles frescos picados
3 hojas de cilantro

Verter la mitad de la leche de coco y el caldo de pollo en una cazuela. Añadir la ralladura de la piel de los 4 limones y llevar a ebullición. Seguidamente, agregar la pechuga de pollo troceada finamente y hervir de nuevo. Añadir el resto de la leche de coco y volver a hervir. Agregar las limas ralladas y remover durante 2 minutos. Finalmente, incorporar el zumo de limón, el caldo de pescado, el azúcar y los chiles. Hervir durante 2 minutos más.
Servir en un bol y decorar con las hojas de cilantro.

250 ml coconut milk
150 ml chicken stock
4 lemons
8 3/4 oz chicken breast
4 limes
20 ml lemon juice
20 ml fish stock
1 1/3 oz sugar
8 fresh chilis, chopped
3 coriander leaves

Pour half of the coconut milk and the chicken stock into a saucepan. Add the grated peel of 4 lemons and bring to a boil. Finely chop the chicken breast, add to the sauce and bring again to a boil. Add the rest of the coconut milk and boil again. Add the grated limes and stir for 2 minutes. Finally, add the lemon juice, the fish stock, the sugar and lastly the chili according to taste. Boil for 2 more minutes.
Serve in a bowl and decorate with the coriander leaves.

250 ml Kokosmilch
150 ml Hühnerbrühe
4 Zitronen
250 g Hühnchenbrust
4 Limetten
20 ml Zitronensaft
20 ml Fischbrühe
40 g Zucker
8 frische gehackte Chilischoten
3 Korianderblätter

Die Hälfte der Kokosmilch und die Hühnerbrühe in einen Topf geben. Die geriebene Zitronenschale der 4 Zitronen hinzugeben und aufkochen lassen. Im Anschluss die fein gewürfelte Hühnchenbrust hinzufügen und erneut aufkochen lassen. Die übrige Kokosmilch dazugeben und weiter kochen lassen. Die Limetten reiben, hinzugeben und 2 Minuten umrühren. Dann den Zitronensaft, die Fischbrühe, den Zucker und die Chilischote hinzugeben und abschmecken. Weitere 2 Minuten kochen lassen.
In einer Schale servieren und mit Korianderblättern dekorieren.

250 ml de lait de coco
150 ml bouillon de volaille
4 citrons
250 g de blanc de poulet
4 citrons verts
20 ml de jus de citron
20 ml de bouillon de poisson
40 g de sucre
8 piments frais hachés
3 feuilles de coriandre

Verser la moitié du lait de coco et le bouillon de volaille dans une casserole. Ajouter les zestes de 4 citrons et porter à ébullition. Ajouter ensuite les blancs de poulet coupés en fines tranches et porter à nouveau à ébullition. Ajouter le reste du lait de coco paursuivre la cuisson. Incorporer les zestes des citrons verts et mélanger 2 minutes. Incorporer le jus de citron, la bouillon de poisson, le sucre et le piment. Rectifier l'assaisonrement. Faire bouillir pendant 2 minutes.
Servir dans un bol et décorer de feuilles de coriandre.

250 ml di latte di cocco
150 ml di brodo di pollo
4 limoni
250 g di petti di pollo
4 limette
20 ml di succo di limone
20 ml di brodo di pesce
40 g di zucchero
8 peperoncini piccanti freschi tritati
3 foglie di coriandolo

Versare la metà del latte di cocco e il brodo di pollo in una pentola. Aggiungere le scorze grattugiate dei 4 limoni e far bollire. Dopodiché, aggiungere il petto di pollo spezzettato e portare nuovamente ad ebollizione. Versarvi il resto del latte di cocco e continuare la cottura. Unire le limette grattugiate e mescolare per 2 minuti. Poi, aggiungere il succo di limone, il brodo di pesce, lo zucchero e i peperoncini piccanti. Cuocere per altri 2 minuti.
Servire in una ciotola e decorare con le foglie di coriandolo.

Can Curreu

Architect: Vicente Mari Tur | Chef: Toni Rodríguez

Ctra. Sant Carles, km 12 | 07850 Santa Eulàlia, Ibiza
Phone: +34 971 335 280
www.cancurreu.com
Opening hours: Mon–Sun 12:30 pm to 4 pm, 7:30 pm to midnight
Average price: € 30
Cuisine: Fresh market Mediterranean cuisine
Special features: Degustation menu

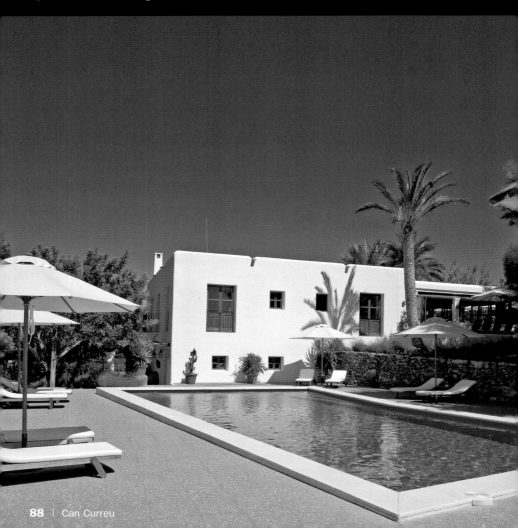

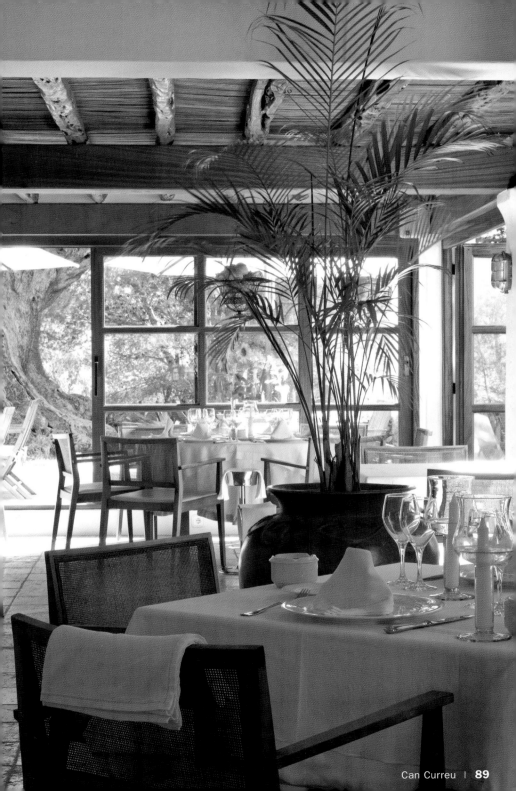

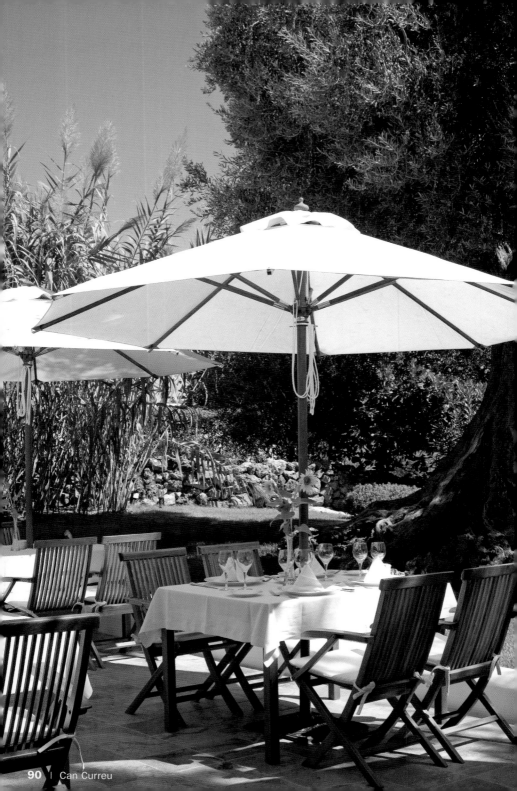

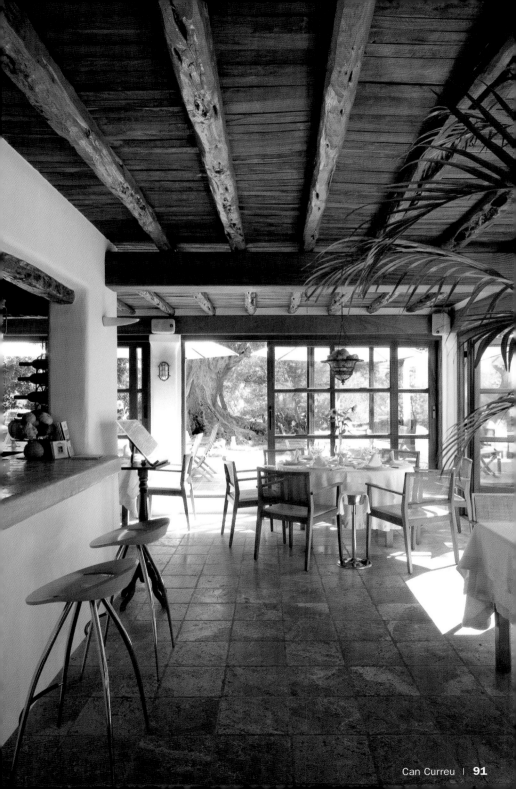

Lomo de cordero
con compota de albaricoque

Loin of Lamb with Apricot Compote

Lammrücken mit Aprikosenkompott

Filet d'agneau avec compote d'abricot

Lombata di agnello con composta di albicocca

100 g de orejones de albaricoque
500 ml de agua
50 ml de coñac
1 vaina de vainilla
1 lomo de cordero
100 g de azúcar
60 ml de salsa de soja
1/2 ramita de canela
Ralladura de la piel de 1 limón
Ralladura de la piel de 1 naranja
Sal

Poner los orejones en remojo en 500 ml de agua y 50 ml de coñac durante 2 horas. A continuación, abrir la vaina de vainilla por la mitad y extraer la pulpa. Agregarla a los orejones y dejar hidratar durante 2 horas. Seguidamente, triturar la mezcla y reservarla. Limpiar el costillar de cordero y eliminar toda la grasa. Marcar en la sartén y salar. Para preparar la salsa, mezclar el azúcar, la salsa de soja, la ramita de canela y la ralladura de limón y naranja en un cazo y reducir a la mitad.
Disponer dos trozos de cordero en el centro del plato, regar con la salsa y decorar con la compota de albaricoque.

3 1/2 oz dried apricots
500 ml water
50 ml cognac
1 vanilla pod
1 loin of lamb
3 1/2 oz sugar
60 ml soy sauce
1/2 cinnamon stick
Grated peel of 1 lemon
Grated peel of 1 orange
Salt

Soak the apricot strips in 500 ml of water and 50 ml of cognac for 2 hours. Open the vanilla pod, extract the pulp and add to the apricots, allowing them to soak for 2 hours. Grind them in the blender and set aside. Clean the rack of lamb and discard all fat. Sear in the pan and season with salt. To prepare the sauce, mix the sugar, soy sauce, cinnamon stick and the grated orange and lemon in a pan and reduce to half the quantity.
Arrange two pieces of the lamb in the center of the plate, dress it with the sauce and decorate with the apricot compote.

100 g getrocknete Aprikosen
500 ml Wasser
50 ml Kognak
1 Vanilleschote
1 Carré vom Lamm
100 g Zucker
60 ml Sojasauce
1/2 Zimtstange
Schale von 1 geriebenen Zitrone
Schale von 1 geriebenen Orange
Salz

Die 500 ml Wasser mit 50 ml Kognak mischen und die getrockneten Aprikosen 2 Stunden lang darin einlegen. Die Vanilleschote aufschneiden, das Mark herauskratzen, zu den Aprikosen geben und weitere 2 Stunden einweichen lassen. Dann im Mixer zerkleinern und zur Seite stellen. Das Carré säubern und das gesamte Fett entfernen. In einer Pfanne anbraten und salzen. Für die Sauce den Zucker, die Sojasauce, die Zimtstange und die geriebenen Zitronen- und Orangenschalen in einen Topf geben und um die Hälfte reduzieren.
Zwei Stückchen Carré mittig auf den Teller geben, mit der Sauce übergießen und das Aprikosenkompott hinzugeben.

100 g d'abricots dénoyautés
500 ml d'eau
50 ml de cognac
1 gousse de vanille
1 carré de agneau
100 g de sucre
60 ml de sauce de soja
1/2 brin de cannelle
L'écorce d'1 citron
L'écorce d'1 orange
Sel

Faire tremper les abricots secs dans 500 ml d'eau et 50 ml de cognac pendant 2 heures. Entailler ensuite la gousse de vanille en deux et en extraire la pulpe. L'ajouter aux abricots et laisser tremper encore 2 heures. Passer ensuite au mixer et réserver. Nettoyer le carré d'agneau et éliminer toute la graisse. Le saisir à la poêle et saler. Pour préparer la sauce, mettre le sucre, la sauce de soja, le brin de cannelle et le zeste de citron et d'orange dans une casserole et réduire de moitié.
Disposer deux morceaux de carré au centre de l'assiette, arroser de sauce et garnir la compote d'abricots.

100 g di albicocche secche
500 ml di acqua
50 ml di cognac
1 baccello di vaniglia
1 carrè di agnello
100 g di zucchero
60 ml di salsa di soia
1/2 bastoncino di cannella
La scorza grattugiata di 1 limone
La scorza grattugiata di 1 arancia
Sale

Mettere a mollo le albicocche secche in 500 ml di acqua e 50 ml di cognac per 2 ore. Successivamente tagliare per il lungo il baccello di vaniglia a metà ed estrarre la polpa. Aggiungerla alle albicocche e lasciare idratare per 2 ore. Dopodiché, tritare nel tritatutto e mettere da parte. Pulire il carrè di agnello ed eliminare tutto il grasso. Scottarlo in padella e salarlo. Per preparare la salsa, mischiare lo zucchero, la salsa di soia, il bastoncino di cannella e le scorze di limone e d'arancia grattugiate e cuocere in un pentolino fino a ridurre a metà volume.
Disporre due pezzetti di carrè al centro del piatto, cospargere di salsa e decorare con la composta di albicocche.

Chill Out Na Xamena

Architect: Alvar Lipszyc I Chef: Oscar Bueno Nilsson

Hacienda Na Xamena, urbanización Na Xamena I 07815 Ibiza
Phone: +34 971 334 500
www.hotelhacienda-ibiza.com
Opening hours: Mon–Sun 4 pm to 8 pm
Average price: € 38
Cuisine: Mediterranean and international cuisine
Special features: The cuisine draws influence on various ethnic cultures

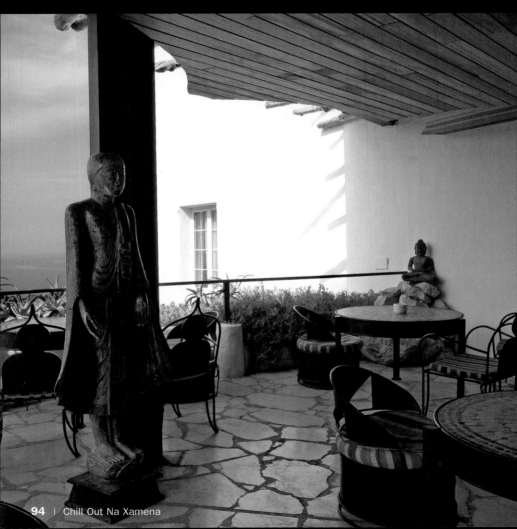

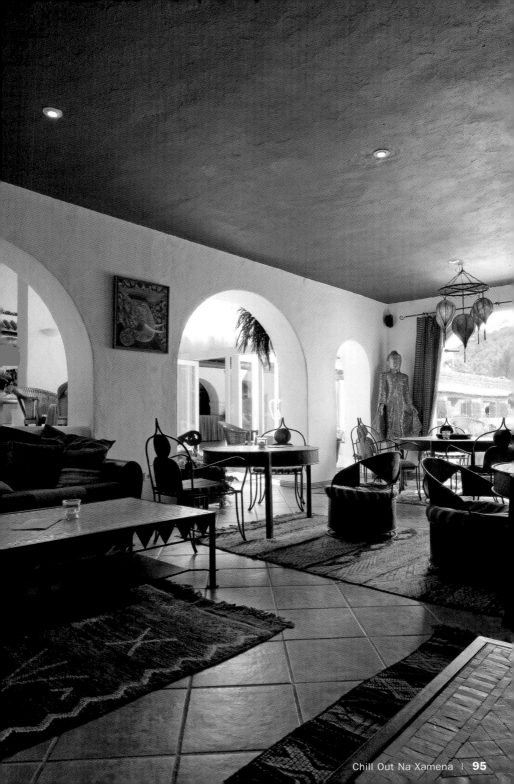

Langostinos
empanados con salsa romesco

Fried King Prawns with Romesco Sauce
Panierte Langusten mit Romesco-Sauce
Langoustines panées sauce romesco
Gamberoni impanati con salsa romesco

12 langostinos
10 g de maíz tostado
100 g de harina
2 huevos
50 ml de aceite de oliva
6 tomates
1/2 cebolla
1 cabeza de ajos
100 g de almendras tostadas
40 g de avellanas
4 rebanadas de pan frito
2 cucharadas de pimentón dulce
1 chorrito de vinagre
Sal

Pelar los langostinos. Triturar el maíz tostado. Rebozar los langostinos en harina, huevo y maíz. Ensartarlos en brochetas y freírlos en aceite de oliva. Para preparar la salsa romesco, asar al horno los tomates, las cebollas y los ajos. Seguidamente, freír las almendras y las avellanas en una sartén con un poco de aceite. Añadir el pan frito, el pimentón, 1 cucharada de aceite y 1 cucharada de vinagre y remover. Rectificar de sal, triturar y pasar por el colador chino.
Disponer en un plato las brochetas pinchadas en 1/2 limón y acompañar con la salsa romesco.

12 king prawns
1/3 oz toasted corn
3 1/2 oz flour
2 eggs
50 ml olive oil
6 tomatoes
1/2 onion
1 garlic head
3 1/2 oz toasted almonds
1 1/3 oz hazelnuts
4 slices fried bread
2 tbsp sweet paprika
1 trickle of vinegar
Salt

Shell the prawns. Grind the toasted corn. Coat the prawns with flour, egg and the toasted corn. Skewer and fry in plenty of hot oil. To prepare the romesco sauce, roast the tomatoes, onions and garlic in the oven. Next, fry the almonds, hazelnuts, and bread in a pan with a bit of oil. Add the paprika, 1 tbsp olive oil and 1 tbsp vinegar and stir. Add salt to taste and puree the mixture.
Place the prawn skewers on 1/2 lemon and accompany with the romesco sauce.

12 Langusten
10 g geröstete Maiskörner
100 g Mehl
2 Eier
50 ml Olivenöl
6 Tomaten
1/2 Zwiebel
1 Knoblauchknolle
100 g geröstete Mandeln
40 g Haselnüsse
4 Scheiben frittiertes Brot
2 EL süßer Paprika
1 Schuss Essig
Salz

Die Langusten schälen. Die Maiskörner im Mixer zerkleinern. Die Garnelen mit Mehl, Ei und den Maiskörnern panieren. Die Garnelen auf Spieße stecken und in reichlich heißem Olivenöl frittieren. Für die Romesco-Sauce im Backofen die Tomaten, die Zwiebeln und den Knoblauch backen. Dann die Mandeln, die Haselnüsse und das Brot in einer Pfanne mit etwas Öl anbraten. Den süßen Paprika, 1 EL Öl und 1 EL Essig hinzugeben und vermischen. Salzen und im Mixer zerkleinern.
Die Langusten auf eine 1/2 Zitrone spießen und die Romesco-Sauce hinzugeben.

12 langoustines
10 g de grains de maïs grillés
100 g de farine
2 œufs
50 ml de huile d'olive
6 tomates
1/2 oignon
1 tête d'ail
100 g d'amandes grillées
40 g de noisettes
4 tranches de pain grillé
2 c. à soupe de piment doux en poudre
1 filet de vinaigre
Sel

Décortiquer les langoustines. Broyer les grains de maïs au mixeur. Rouler les langoustines dans la farine, l'œuf et les grains de maïs broyés. Les enfiler sur une brochette et les frire dans l'huile d'olive. Pour préparer la sauce romesco, rôtir au four les tomates, les oignons et les gousses d'ail. Faire revenir les amandes, les noisettes et le pain grillé dans une poêle avec un peu de huile. Ajouter le piment doux en poudre, 1 c. à soupe d'huile d'olive, 1 c. à soupe de vinaigre, mélanger et passer au chinois. Rectifier l'assaisonnement.
Disposer les brochettes de langoustines piquées dans un 1/2 citron sur l'assiette et accompagner de sauce romesco.

12 gamberoni
10 g di mais tostato
100 g di farina
2 uova
50 ml d'olio d'oliva
6 pomodori
1/2 cipolla
1 testa d'aglio
100 g di mandorle tostate
40 g di nocciole
4 fette di pane fritto
2 cucchiai di paprica dolce
1 spruzzo di aceto
Sale

Pelare i gamberoni. Triturare il mais tostato. Impanare i gamberoni con la farina, l'uovo e il mais. Infilzarli su spiedini e friggerli in abbondante olio d'oliva. Per preparare la salsa romesco, cuocere i pomodori, le cipolle e gli spicchi d'aglio al forno. Dopodiché, friggere le mandorle, le nocciole e il pane in una padella con un filo d'olio. Aggiungere la paprica dolce, 1 cucchiaio d'olio e 1 cucchiaio d'aceto e mescolare. Correggere di sale e filtrare con il colino cinese. Disporre su un piatto gli spiedini di gamberoni infilzati in 1/2 limone e accompagnare con la salsa romesco.

Edèn Na Xamena

Architect: Alvar Lipszyc | Chef: Oscar Bueno Nilsson

Hacienda Na Xamena, urbanización Na Xamena | 07815 Ibiza
Phone: +34 971 334 500
www.hotelhacienda-ibiza.com
Opening hours: Mon–Sun 1 pm to 4 pm, 8 pm to 11 pm
Average price: € 40
Cuisine: Market cuisine
Special features: Healthy and nutritious cuisine. Aromas and taste sensations with character for the well-being of the diners

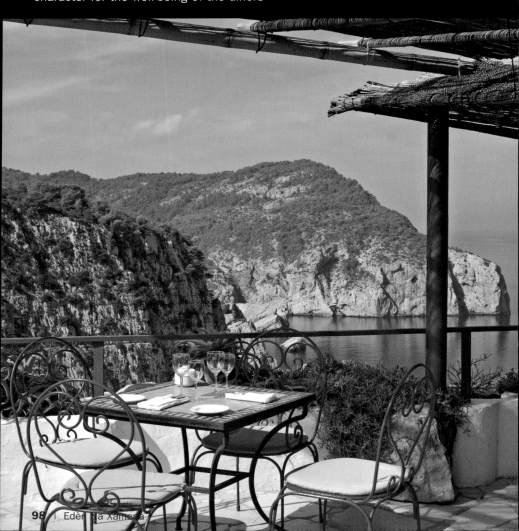

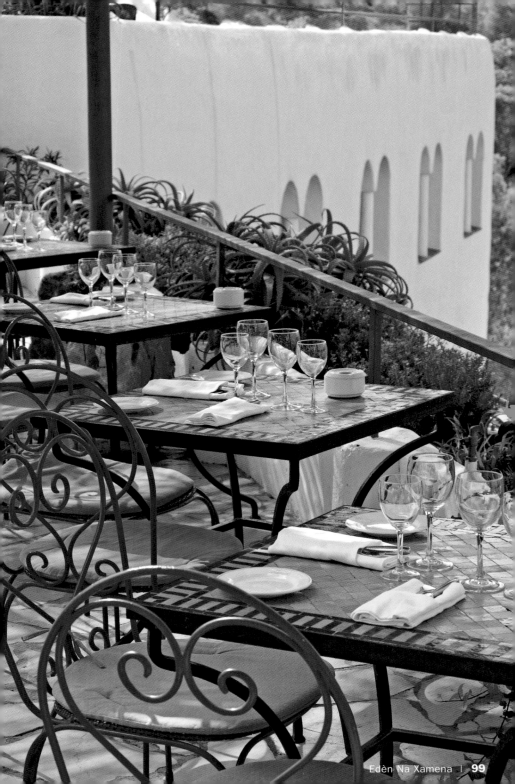

Salmón

con ragú de limón

Salmon with Lemon Ragout

Lachs mit Zitronenragout

Saumon avec ragoût de citrons

Salmone con ragù di limone

1 filete de salmón
15 ml de aceite de oliva
2 limones
100 g de azúcar
25 g de caviar rojo
2 algas nori

Cortar el filete de salmón en dos 2 piezas. Dorarlas en una sartén con unas gotas de aceite y terminar de cocerlas en el horno. Lavar los limones y pelarlos. Reservar la piel e introducirlos en un cazo con agua hirviendo; cocer durante 15 minutos. Reservar. Cortar la piel de los limones en tiras finas y hervirlas durante 1/2 hora junto con el azúcar hasta obtener un jarabe. Introducir los limones ya hervidos en este jarabe durante unos minutos. El jarabe no debe quedar demasiado dulce.
En un plato rectangular disponer un lecho de ragú de limón. Encima colocar el salmón y coronarlo con el caviar. Decorar con algas nori.

1 salmon filet
15 ml olive oil
2 lemons
3 1/2 oz sugar
1 oz red caviar
2 Nori seaweed

Cut the salmon filet in two 2 pieces. Lightly fry in a pan with a few drops of olive oil and finish cooking them in the oven. Clean and peel the lemons. Keep the peel and place the lemons in a saucepan with boiling water and cook for 15 minutes. Set aside. Cut the lemon peel into thin strips and boil for a 1/2 hour with the sugar until obtaining a syrup. Add the lemons to the syrup and stir for a few minutes. The syrup should not be excessively sweet.
On a rectangular plate spread a layer of the lemon ragout. Place the salmon on top and crown with the caviar. Decorate with the Nori seaweed.

1 Lachsfilet
15 ml Olivenöl
2 Zitronen
100 g Zucker
25 g Ketakaviar (roter Kaviar)
2 Nori-Algen

Das Lachsfilet in 2 Stücke schneiden. In der Pfanne mit ein paar Tropfen Öl leicht anbraten und im Backofen weiter garen lassen. Die Zitronen waschen und schälen. Die geschälten Zitronen in einen Topf mit kochendem Wasser geben und 15 Minuten lang kochen. Zur Seite stellen. Dann die Zitronenschale in feine Streifen schneiden und 1/2 Stunde lang mit dem Zucker zu einem Sirup einkochen lassen. Die gekochten Zitronen in den Sirup geben und einige Minuten weiter köcheln lassen. Der Sirup darf nicht zu süß sein. Auf einen rechteckigen Teller drei Häufchen Zitronenragout geben. Darauf die Lachsstücke anordnen, mit dem Ketakaviar krönen. Mit Nori-Algen dekorieren.

1 filet de saumon
15 ml d'huile d'olive
2 citrons
100 g de sucre
25 g de caviar rouge
2 algues nori

Couper le filet de saumon en 2. Le faire revenir légèrement dans une poêle avec quelques gouttes d'huile et terminer la cuisson au four. Laver les citrons et en ôter l'écorce et la réserver. Faire bouillir les citrons épluchés 15 minutes. Réserver. Couper l'écorce des citrons en fines lamelles et les faire bouillir 1/2 heure avec le sucre jusqu'à obtention d'un sirop. Introduire les citrons dans le sirop quelques minutes. Vérifier que le résultat obtenu n'est pas trop sucré. Sur une assiette rectangulaire disposer un peu de ragoût de citrons. Y déposer le saumon et couronner de caviar rouge. Décorer avec des algues nori.

1 filetto di salmone
15 ml d'olio d'oliva
2 limoni
100 g di zucchero
25 g di caviale rosso
2 alghe nori

Tagliare il filetto di salmone in 2 porzioni. Dorarle in una padella con poche gocce d'olio e ultimare la cottura in forno. Lavare i limoni e sbucciarli. Mettere da parte la scorza e immergere i limoni in una pentola con acqua bollente; farli cuocere per 15 minuti. Mettere da parte. Tagliare la scorza dei limoni a listelle fini e farle bollire per 1/2 ora assieme allo zucchero fino ad ottenere uno sciroppo. Immergere i limoni lessati nello sciroppo e cuocere a fuoco lento per alcuni minuti. Lo sciroppo non deve essere eccessivamente dolce. In un piatto rettangolare formare un letto di ragù di limone. Collocarvi sopra il salmone e disporvi sopra il caviale. Decorare con le alghe nori.

El Ayoun

Architect: Charles Delfortie

Isidor Macabich s/n | 07816 San Rafael, Ibiza
Phone: +34 971 198 335
www.elayoun-ibiza.com
Opening hours: Mon–Sun 12:30 am to 3 pm, 8 pm to midnight
Average price: € 40
Cuisine: Moroccan
Special features: Moroccan style ambience and decoration

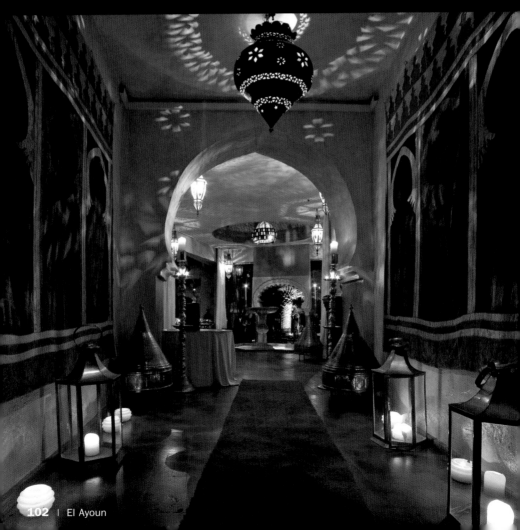

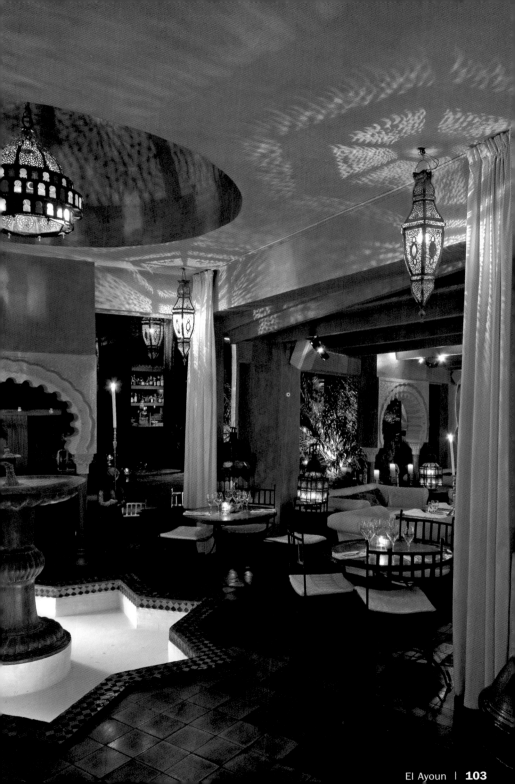

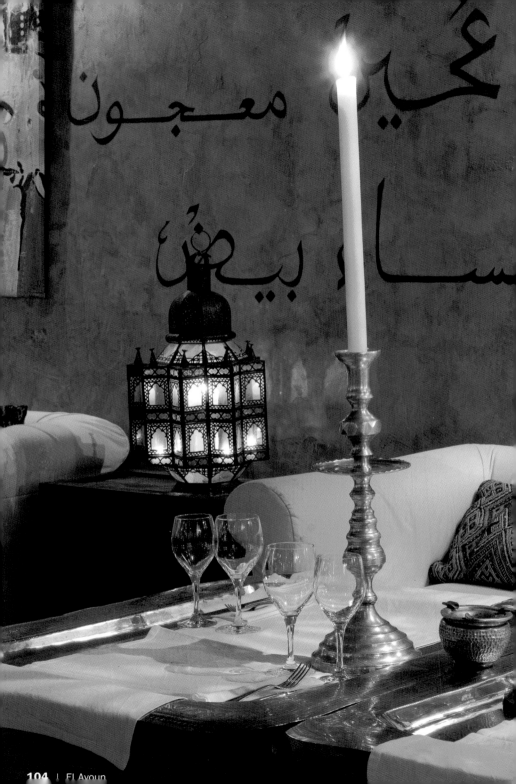

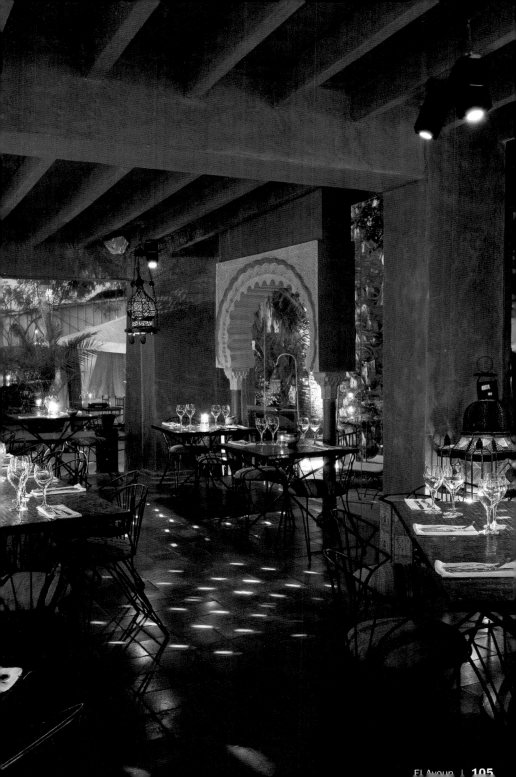

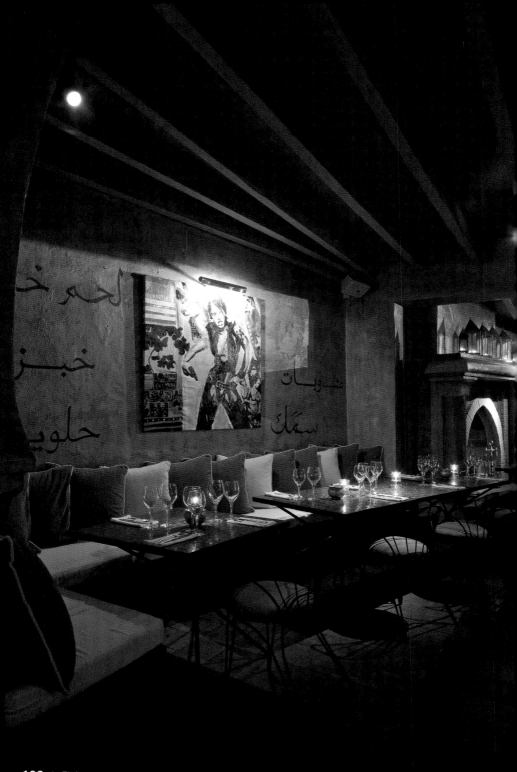

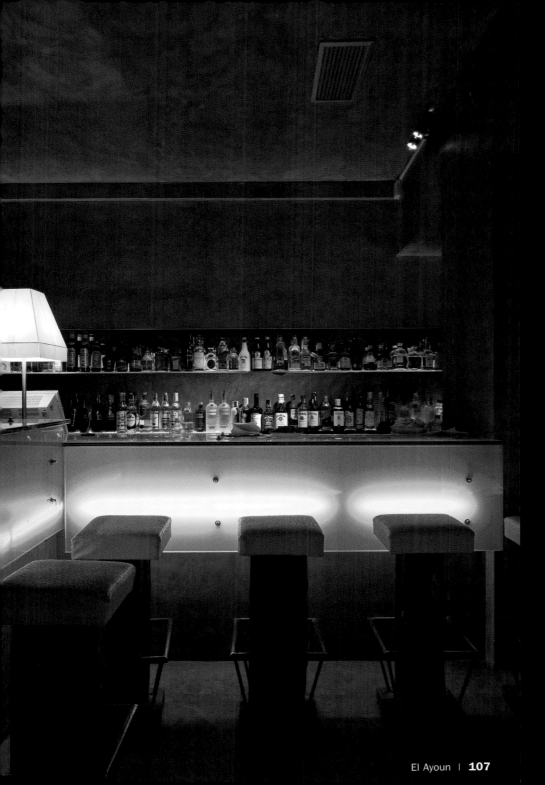

Cordero

con arroz

Lamb with Rice
Lammfleisch mit Reis
Agneau au riz
Agnello con riso

250 g de cordero
1 cabeza de ajos
10 g de comino
50 g de mantequilla
50 g de manteca
800 g de arroz largo
900 ml de caldo de carne
Sal

Cortar la carne de cordero en tiras y ensartarlas en una brocheta. Marcarla en la parrilla. Machacar en un mortero los ajos y el comino. Mezclar con la mantequilla fundida y untar el corde-ro con esta mezcla. Cocer el cordero en una cazuela dándole la vuelta constantemente durante 1 hora y untándolo de vez en cuando con la mezcla. Para el arroz, calentar la manteca en una cazo, verter el arroz y dejar que se hinchen los granos removiendo continuamente. Condimentar con sal y agregar el caldo caliente. Remover y llevar a ebullición. Reducir a fuego suave y cocer durante 15 minutos. Dejar reposar durante 10 minutos antes de servir.
Disponer la carne en el centro del plato y regar con el jugo del cordero. Acompañar con el arroz.

9 oz lamb
1 garlic head
1/3 oz cumin
1 3/4 oz melted butter
1 3/4 oz lard
1 lb 12 1/4 oz long grain rice
900 ml of meat stock
Salt

Cut the lamb into strips, skewer and sear on the grill. Crush the garlic and cumin in a mortar, mix with the melted butter and spread over the lamb. Cook the lamb in a saucepan for 1 hour, turning it over constantly and occasionally apply-ing the paste. To prepare the rice, heat the lard in a saucepan, pour in the rice and stir continuously. Season with salt and add the hot stock. Stir and bring to a boil. Reduce to low heat and simmer for 15 minutes. Set aside 10 minutes before serving.
Serve the meat in the center of the plate and dress with its own sauce. Accompany with the rice.

250 g Lammfleisch
1 Knoblauchknolle
10 g Kreuzkümmel
50 g Butter
50 g Schweineschmalz
800 g Langkornreis
900 ml Fleischbrühe
Salz

Das Lammfleisch in Streifen schneiden und aufspießen. Auf den Grill legen. Den Knoblauch und den Kreuzkümmel in einem Mörser zerstampfen. Mit der geschmolzenen Butter vermengen und das Lammfleisch mit dieser Mischung bestreichen. Das Lammfleisch 1 Stunde lang unter ständigem Umdrehen in einem Schmortopf kochen und es von Zeit zu Zeit ein wenig mit der Paste aus Knoblauch, Kreuzkümmel und Butter einreiben. Für den Reis den Schmalz in einem Topf erhitzen, den Reis hinzugeben und die Körner umrühren, bis sie aufgequollen sind. Salzen und die heiße Fleischbrühe hinzugeben. Rühren und aufkochen lassen. 15 Minuten lang auf kleiner Flamme kochen lassen. Vor dem Servieren 10 Minuten ruhen lassen.
Das Fleisch in der Mitte des Tellers anordnen und mit dem aufgefangenem Bratensaft übergießen. Den Reis als Beilage hinzugeben.

250 g d'agneau
1 tête d'ail
10 g de cumin
50 g de beurre
50 g de saindoux
800 g de riz au grain long
900 ml de bouillon de viande
Sel

Couper la viande d'agneau en lanière. Mettre la viande en brochette et la faire griller sur un barbecue. Dans un mortier, écraser les gousses d'ail, le cumin. Mélanger avec le beurre fondu et enduire l'agneau de ce mélange. Cuire l'agneau en le retournant constamment pendant 1 heure. Continuer à l'enduire de temps en temps de la préparation à base d'ail, de cumin et de beurre. Pour préparer le riz, chauffer le saindoux dans une casserole, verser le riz et laisser gonfler les grains sans cesser de remuer. Saler et ajouter le bouillon chaud. Remuer et porter à ébullition. Réduire à feu doux et cuire pendant 15 minutes. Laisser reposer pendant 10 minutes avant de servir.
Déposer la viande au centre de l'assiette et arroser du jus de viande. Accompagner de riz.

250 g di agnello
1 testa d'aglio
10 g di cumino
50 g di burro
50 g di strutto
800 g di riso lungo
900 ml di brodo di carne
Sale

Tagliare la carne di agnello a strisce e infilarle in spiedini. Scottarla alla piastra. Pestare in un mortaio gli spicchi d'aglio e il cumino. Amalgamare con il burro fuso e ungere la carne con il composto ottenuto. Cuocere la carne d'agnello in una pentola per 1 ora avendo cura di girarla continuamente su entrambi i lati e ungendola di tanto in tanto con un po' del composto formato da aglio cumino e burro. Per il riso, riscaldare lo strutto in una casseruola, versarvi il riso e lasciare che i chicchi si gonfino senza smettere di mescolare. Salare e aggiungere il brodo caldo. Mescolare e portare ad ebollizione. Cuocere a fuoco lento per 15 minuti. Lasciare riposare per 10 minuti prima di servire.
Disporre la carne al centro del piatto e cospargere con il sugo lasciato dalla carne durante la cottura. Accompagnare con il riso.

Es Torrent

Architect: Xicu Sala | Chef: Bartolomé Tur

Porroig, Playa Es Torrent | San José, Ibiza
Phone: +34 971 802 160
www.estorrent.net
Opening hours: Mon–Sun 1 pm to 10 pm
Average price: € 35
Cuisine: Mediterranean
Special features: Located in the delightful beach cove of Es Torrent, offering fish of the day, seafood straight from the in house hatchery and noodle dishes

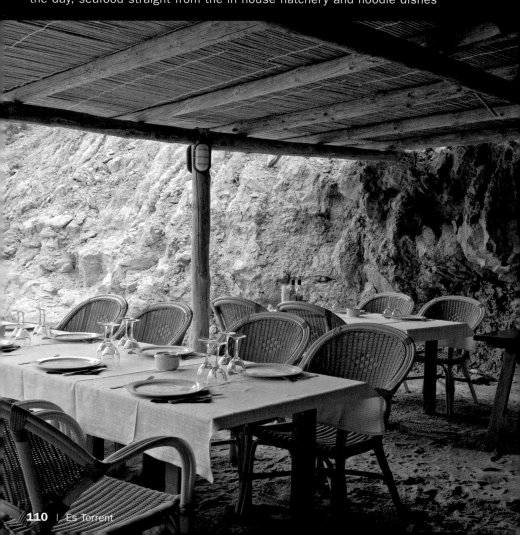

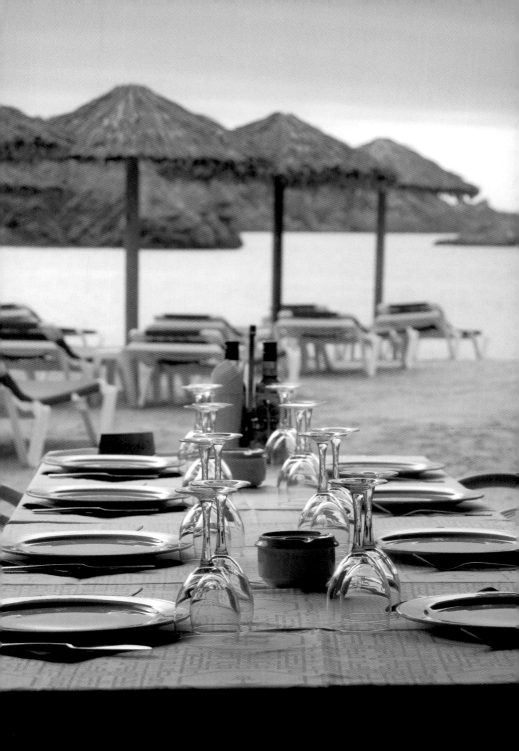

Dorada al horno
con patatas

Oven Baked Bream and Potatoes
Gebackene Goldbrasse mit Kartoffeln
Dorade au four aux pommes de terre
Orata al forno con patate

1 dorada de 1 kg
50 ml de aceite de oliva
500 g de patatas
1 cebolla
2 dientes de ajo
2 tomates
1 hoja de laurel
1 ramita de perejil
100 ml de coñac
100 ml de vino blanco
Pimienta blanca
Sal

Untar una bandeja para horno con 30 ml de aceite de oliva. Pelar y cortar las patatas en rodajas finas y distribuirlas en la bandeja. Salpimentar. Disponer la dorada sobre las patatas limpia y salpimentada. Picar la cebolla y el ajo y cortar los tomates en rodajas. Cubrir el pescado con las verduras. Picar la hoja de laurel y la ramita de perejil y espolvorear sobre la dorada. Rociar con el coñac y el resto del aceite y regar con el vino blanco. Hornear a temperatura media durante 40 minutos.
Disponer la dorada en una fuente y utilizar el mismo jugo de la cocción como salsa.

2 lb 3 oz bream
50 ml of olive oil
1 lb 1 1/2 oz potatoes
1 onion
2 garlic cloves
2 tomatoes
1 bay leaf
1 sprig parsley
100 ml of cognac
100 white wine
White pepper
Salt

Grease the baking tray with 30 ml of olive oil. Peel and finely slice the potatoes. Place inside the baking tray and season with salt and pepper. Place the clean and salted bream over the potatoes. Chop the onion and garlic, slice the tomatoes and cover the fish with the vegetables. Chop the bay leaf and parsley and sprinkle over the fish. Pour over with brandy, the rest of the olive oil and white wine. Bake in a medium hot oven for 40 minutes.
Serve the fish in a tray using its own juices as sauce.

1 Goldbrasse à 1 kg
50 ml Olivenöl
500 g Kartoffeln
1 Zwiebel
2 Knoblauchzehen
2 Tomaten
1 Lorbeerblatt
1 Petersilienzweig
100 ml Kognak
100 ml Weißwein
Weißer Pfeffer
Salz

Ein Backofenblech mit 30 ml Olivenöl bestreichen. Die Kartoffeln schälen und in feine Scheiben schneiden. Auf das Blech geben, salzen und pfeffern. Die gesäuberte, gesalzene und gepfefferte Goldbrasse auf die Kartoffeln legen. Die Zwiebel und den Knoblauch hacken. Die Tomaten in Scheiben schneiden. Das Gemüse auf dem Fisch verteilen. Das Lorbeerblatt und den Petersilienzweig hacken und auf die Goldbrasse geben. Mit Brandy, dem restlichen Öl und zuletzt mit dem Weißwein begießen. Bei mittlerer Temperatur 40 Minuten backen.
Die Goldbrasse auf einen Servierteller geben und den Kochsud als Sauce benutzen.

1 dorade de 1 kg
50 ml d'huile d'olive
500 g de pommes de terre
1 oignon
2 gousses d'ail
2 tomates
1 feuille de laurier
1 brin de persil
100 ml de cognac
100 ml de vin blanc
Poivre blanc
Sel

Verser 30 ml d'huile d'olive dans un plat allant au four. Laver, éplucher et couper les pommes de terre en tranches fines. Les répartir dans le plat et assaisonner. Poser la dorade lavée et assaisonnée sue les pommes de terre. Emincer l'oignon et les gousses d'ail. Couper les tomates en rondelles. Répartir les légumes au-dessus du poisson. Hacher la feuille de laurier et le brin de persil et les saupoudrer au-dessus de la dorade. Arroser de cognac, d'un filet d'huile et de vin blanc. Enfourner à température moyenne 40 minutes.
Disposer sur un plat et utiliser le jus de cuisson pour la sauce.

1 orata da 1 kg
50 ml d'olio d'oliva
500 g di patate
1 cipolla
2 spicchi d'aglio
2 pomodori
1 foglia d'alloro
1 rametto di prezzemolo
100 ml di cognac
100 ml di vino bianco
Pepe bianco
Sale

Ungere una teglia da forno con 30 ml d'olio d'oliva. Pelare e tagliare le patate a rondelle sottili e distribuirle sulla teglia. Salare e pepare. Adagiare l'orata pulita, salata e pepata sulle patate. Tritare la cipolla e l'aglio e tagliare i pomodori a rondelle. Coprire il pesce con le verdure. Tritare la foglia d'alloro e il rametto di prezzemolo e spolverarvi l'orata. Bagnare con il cognac, il resto dell'olio e da ultimo con il vino bianco. Cuocere al forno ad una temperatura media per 40 minuti.
Disporre l'orata su un vassoio e condire con lo stesso brodo di cottura.

La Brasa

Architect: Salvador Oliver | Chef: Carmen Borruel

c/ Pere Sala, 3 | 07800 Ibiza
Phone: + 34 971 301 202
Opening hours: Summer Mon–Sun 1 pm to 1 am, winter Mon–Sat 1 pm to midnight
Average price: € 30
Cuisine: Mediterranean
Special features: In the summertime the courtyard is an ideal place to dine

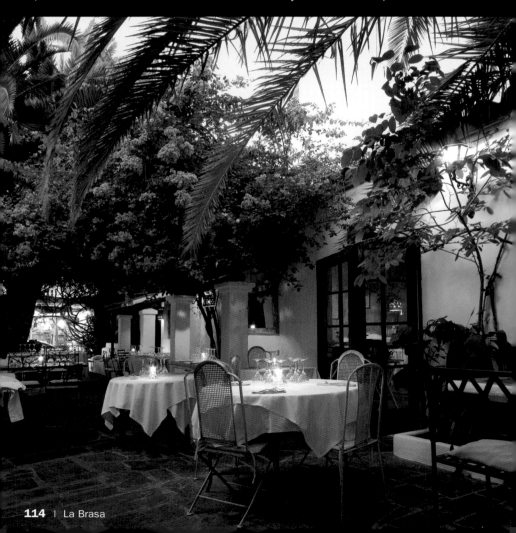

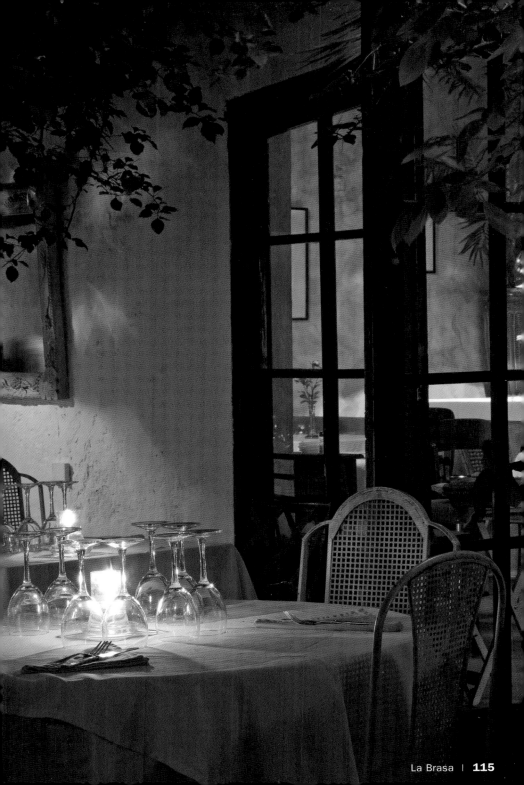

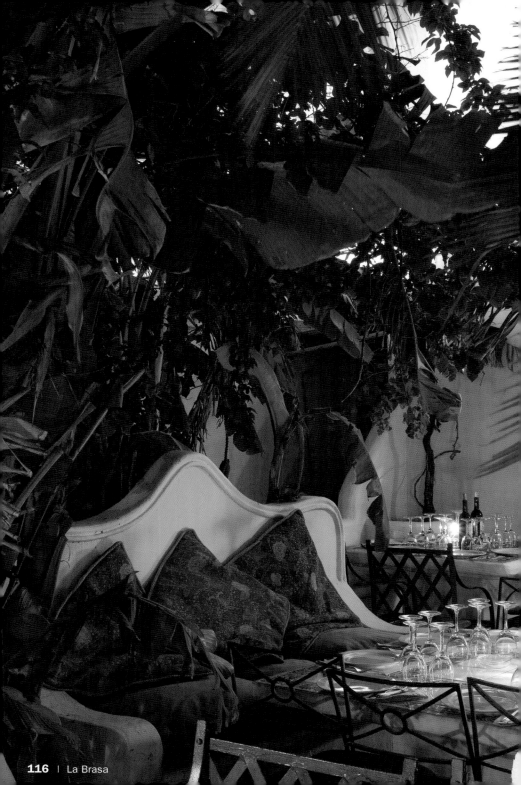

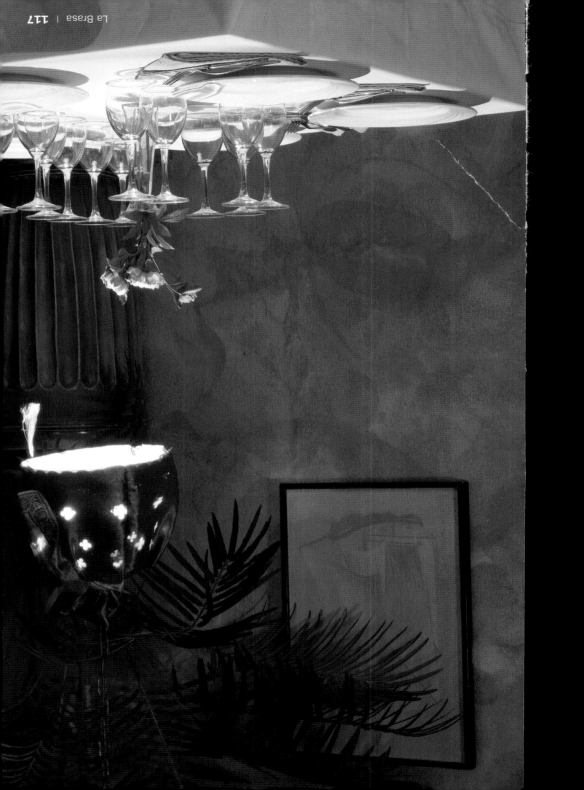

L'Elephant

Design: Gil French-Keogh, Raymond Bruno | Chef: Victor Trochi

Plaza de la Iglesia | 07816 San Rafael, Ibiza
Phone: +34 971 198 056/+34 971 198 354
www.elephant-ibiza.com
Opening hours: Mon–Sun 8 pm to 4 am
Average price: € 50
Cuisine: French and international cuisine
Special features: Panoramic view of Ibiza from the terrace and elegant dining area

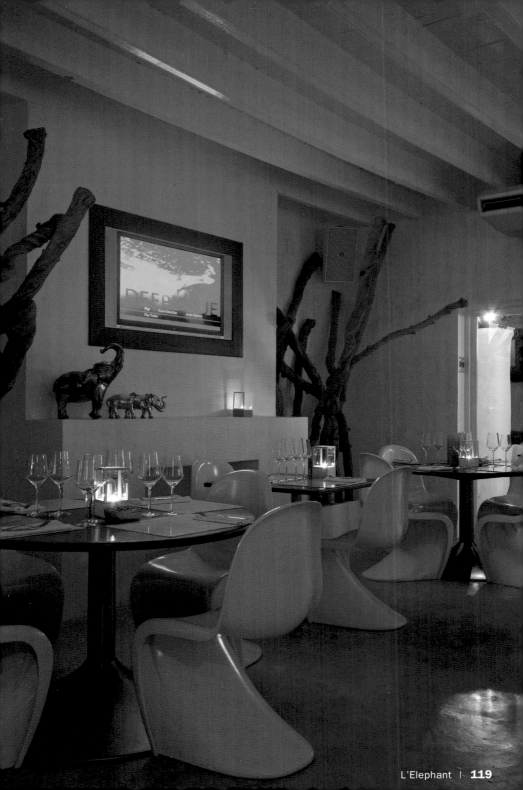

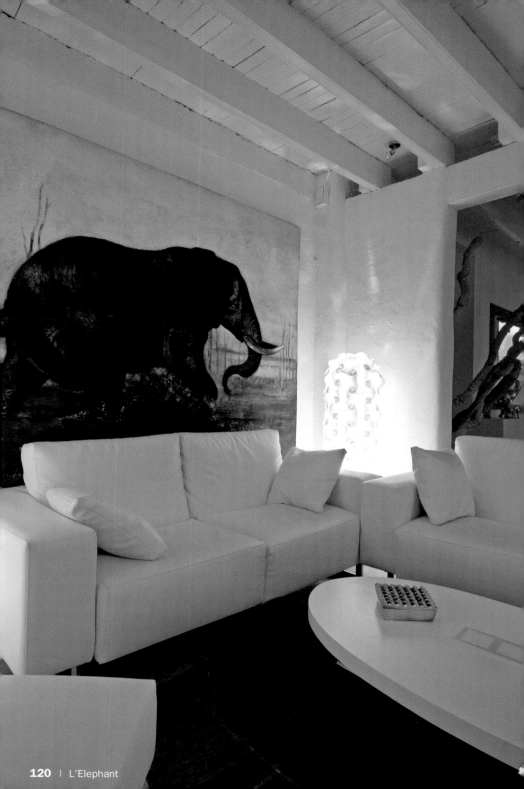

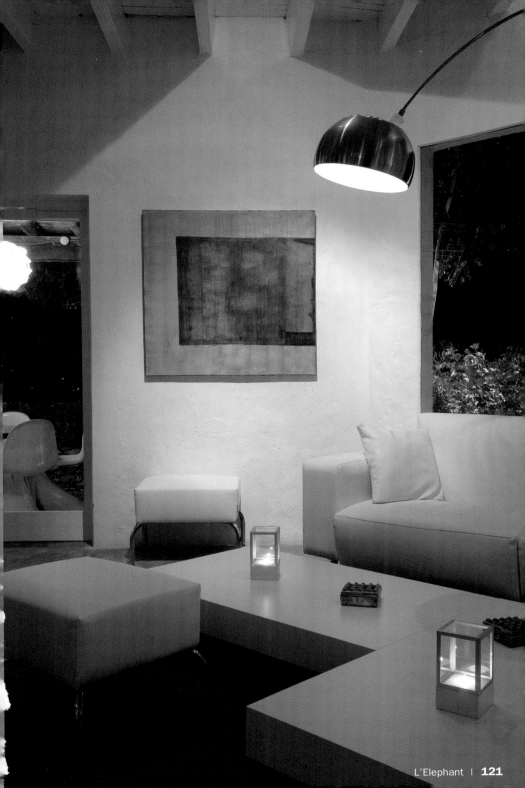

Bacalao

a la plancha con caviar

Grilled Cod with Caviar
Kabeljau auf heißer Platte mit Kaviar
Morue au gril accompagnée de caviar
Merluzzo alla piastra con caviale

1 filete de bacalao fresco
50 g de harina
15 ml de aceite de oliva
1 zanahoria
1 pimiento verde
1 calabacín
25 g de caviar
Sal y pimienta

Limpiar el bacalao, trocearlo y salpimentarlo. Pasarlo por un poco de harina y freírlo a la plancha con aceite de oliva procurando que no quede demasiado seco. Trocear las verduras y saltearlas en una sartén con aceite de oliva.
Disponer en un plato el bacalao coronado con el caviar y acompañado de las verduras.

1 slice of fresh cod
1 3/4 oz flour
15 ml olive oil
1 carrot
1 green pepper
1 zucchini
7/8 oz caviar
Salt and pepper

Clean the cod, cut it into pieces and season with salt and pepper. Lightly flour and grill with olive oil, making sure it doesn't dry. Slice the vegetables and sauté in a bit of olive oil.
Serve the cod and crown with the caviar. Accompany with the vegetables.

1 frisches Kabeljaufilet
50 g Mehl
15 ml Olivenöl
1 Möhre
1 grüne Paprika
1 Zucchini
25 g Kaviar
Salz und Pfeffer

Den Kabeljau putzen und in Stückchen schneiden. Pfeffern und salzen. In etwas Mehl wälzen und auf der heißen Metallplatte mit ein paar Tropfen Öl anbraten. Wenn er langsam goldgelb wird, den Kabeljau umdrehen, damit er nicht zu trocken wird. Die Gemüse in Streifen schneiden und mit etwas Olivenöl in der Pfanne sautieren.
Das Kabeljaufilet auf einem Teller anrichten und mit dem Kaviar krönen. Die Gemüsestreifen als Beilage hinzugeben.

1 filet de morue fraîche
50 g de farine
15 ml d'huile d'olive
1 carotte
1 poivron vert
1 courgette
25 g de caviar
Sel et poivre

Nettoyer la morue, la couper en morceaux, saler et poivrer. L'enduire d'un peu de farine et la faire griller sur le gril avec quelques gouttes d'huile. Veiller à ce qu'elle ne se dessèche pas. Couper les légumes et les faire revenir à la poêle dans un peu d'huile d'olive.
Déposer la morue dans une assiette, couronner de caviar et accompagner de légumes.

1 filetto di merluzzo fresco
50 g di farina
15 ml d'olio d'oliva
1 carota
1 peperone verde
1 zucchino
25 g di caviale
Sale e pepe

Lavare il merluzzo, tagliarlo a pezzi, salarlo e peparlo. Infarinarlo leggermente e scottarlo su una piastra con un po' d'olio d'oliva avendo cura che non si secchi troppo. Tagliare le verdure e saltarle in una padella con un po' d'olio d'oliva. Disporre su un piatto il merluzzo e adagiarvi sopra il caviale. Accompagnare con le verdure.

Sa Capella

Chef: Agustín

San Antonio | 07840 Ibiza
Phone: +34 971 340 057
Opening hours: Mon–Sun Apr–May, Sep–Oct 8 pm to midnight, Jun–Aug 8:30 pm to 12:30 am, closed Nov–Mar
Average price: € 40
Cuisine: Mediterranean and international cuisine
Special features: 16th century church with a unique and mysterious ambience

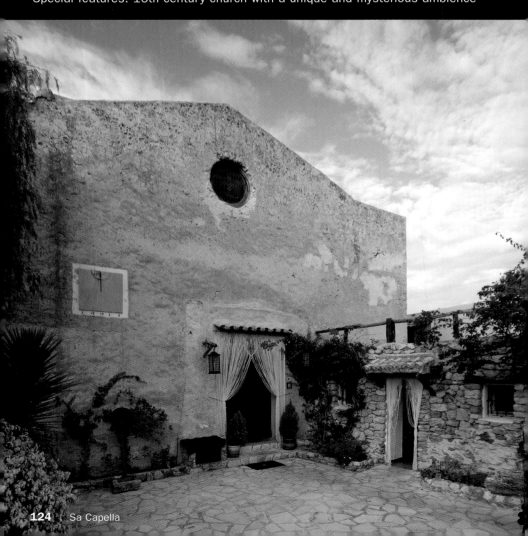

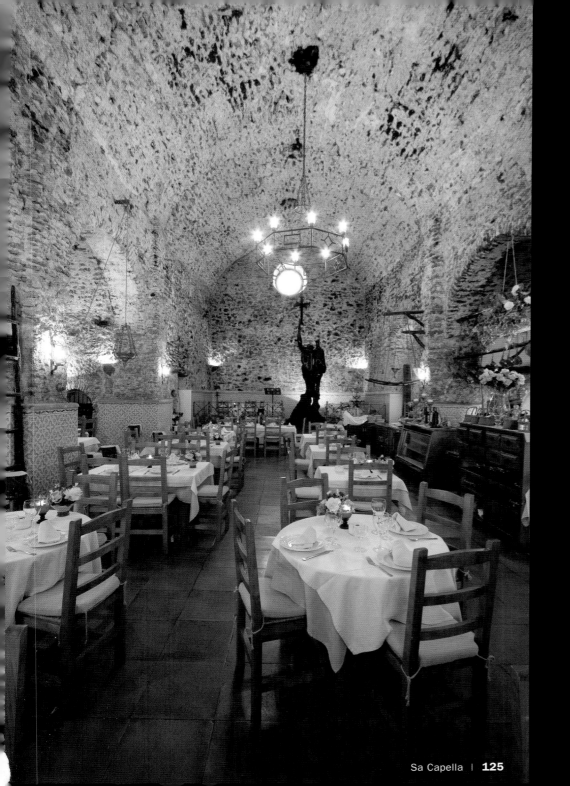

Sol d'en Serra

Chef: Sol

Cala Llonga | Santa Eulàlia, Ibiza
Phone: +34 971 196 176
www.soldenserra.com
Opening hours: Mon–Sun from noon to midnight
Average price: € 25
Cuisine: International
Special features: Terrace with fantastic sea views, an ideal place for romantic dinners

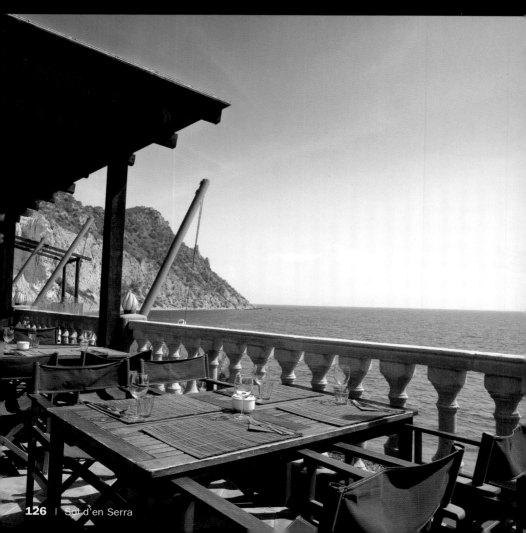

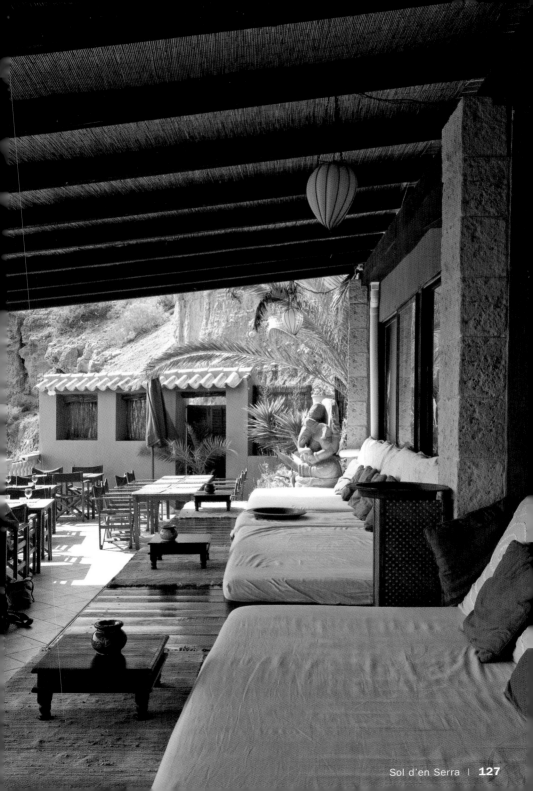

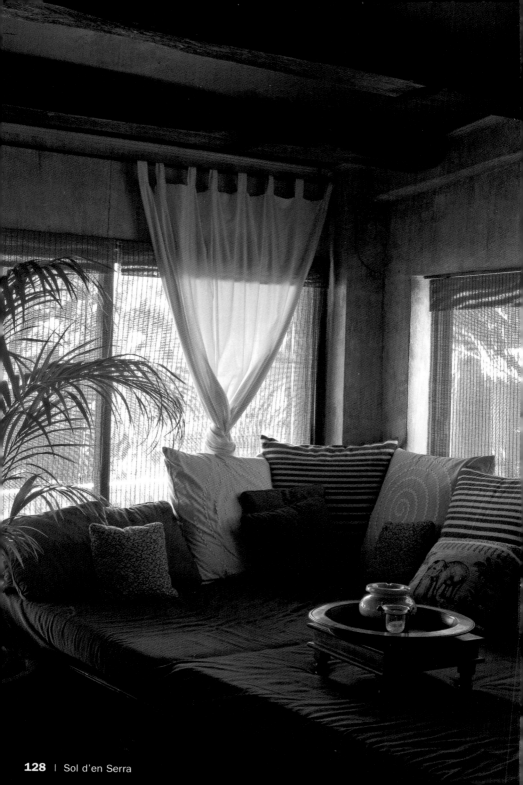

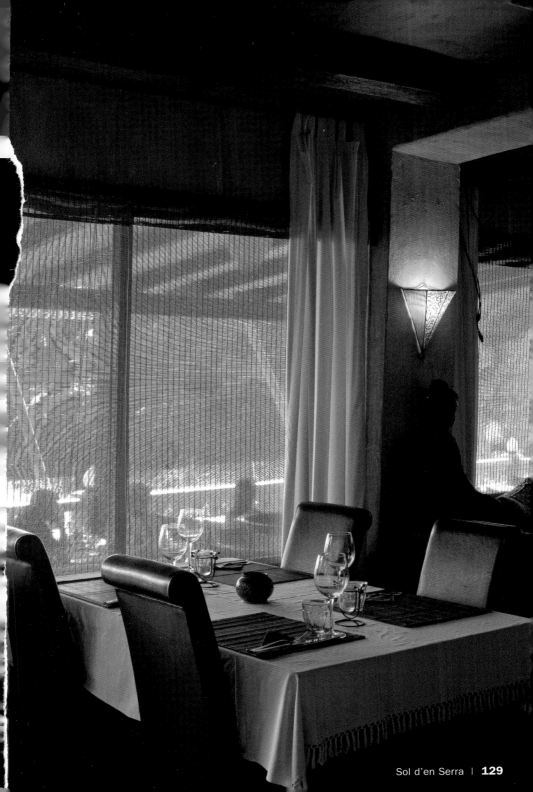

Mousse

de chocolate con galleta

Chocolate Mousse with Biscuit

Mousse au chocolat mit Biskuit

Mousse au chocolat et au biscuit

Mousse di cioccolato su cialda di biscotto

150 g de chocolate negro (al 55% de cacao)
100 g de nata líquida
50 g de mantequilla
5 yemas de huevo
8 claras de huevo
100 g de azúcar
25 g de harina
1 ramita de menta

Fundir el chocolate al baño maría. Agregar la nata líquida y la mantequilla y ligar todos los ingredientes. A continuación, añadir 2 yemas de huevo y, por último, 5 claras de huevo montadas a punto de nieve con 30 g de azúcar. Remover suavemente. Para preparar la galleta, montar 3 claras de huevo a punto de nieve y mezclarlas con 70 g azúcar hasta formar una pasta homogénea. Agregar 3 yemas de huevo y remover. Finalmente, añadir la harina y mezclar. Extender la galleta en papel de estraza hasta obtener una lámina rectangular y hornear a 180 °C durante 10 minutos.
Verter la mousse sobre la galleta con una manga pastelera y servir. Decorar con una ramita de menta.

5 1/4 oz dark chocolate (55% cacao)
3 1/2 oz single cream
1 3/4 oz butter
5 egg yolks
8 egg whites
3 1/2 oz sugar
7/8 oz flour
1 sprig of mint

Melt the chocolate in a double boiler. Add the cream and the butter and mix together. Next, add 2 egg yolks, and 5 egg whites beaten with 1 oz sugar until light. Gently stir. To prepare the biscuit, whisk 3 egg whites until light and mix with 2 1/2 .oz sugar to make a homogenous paste. Add 3 egg yolks and stir. Finally, add the flour and mix. Spread the biscuit over the rag paper in a rectangular sheet and cook at 360 °F for 10 minutes.
Pour the mousse onto the biscuit with a piping bag and serve. Decorate with a sprig of fresh mint.

150 g dunkle Schokolade (55% Kakaoanteil)
100 g Sahne
50 g Butter
5 Eigelb
8 Eiweiß
100 g Zucker
25 g Mehl
1 Zweig Minze

Die Schokolade im Wasserbad schmelzen lassen. Die Sahne und die Butter hinzugeben und alle Zutaten binden. Anschließend 2 Eigelb und zuletzt die 5, mit 30 g Zucker steif geschlagenen, Eiweiß hinzugeben. Vorsichtig unterheben. Für die Zubereitung des Biskuits 3 Eiweiß steif schlagen und mit 70 g Zucker mischen, bis eine einheitliche Creme entsteht. 3 Eigelb hinzugeben und gut umrühren. Schließlich das Mehl hinzugeben und vorsichtig unterrühren. Das Biskuit auf einem Stück Backpapier ausrollen, bis man ein rechtwinkliges Stück erhält und dieses dann 10 Minuten lang bei 180 °C backen.
Die Mousse mit einem Spritzbeutel auf den Biskuit geben und servieren. Mit der Minze dekorieren.

150 g de chocolat noir (à 55% de cacao)
100 g de crème liquide
50 g de beurre
5 jaunes d'œuf
8 blancs d'œuf
100 g de sucre
25 g de farine
1 brin de menthe

Fondre le chocolat au bain-marie. Ajouter la crème et le beurre et mélanger tous les ingrédients. Ajouter 2 jaunes d'œuf et, en dernier, incorporer délicatement 5 blancs montés en neige avec 30 g de sucre. Pour préparer le biscuit, monter 3 blancs en neige et les mélanger avec 70 g de sucre jusqu'à ce qu'ils soient très fermes. Ajouter 3 jaunes et bien remuer. Incorporer la farine, et mélanger délicatement. Etaler la pâte à biscuit sur du papier de cuisson pour obtenir un rectangle allongé et faire cuire au four à 180 °C pendant 10 minutes.
Déposer la mousse sur le biscuit avec une poche à douille et servir. Décorer d'un brin de menthe.

150 g di cioccolato nero (al 55% di cacao)
100 g di panna liquida
50 g di burro
5 tuorli d'uovo
8 albumi d'uovo
100 g di zucchero
25 g di farina
1 rametto di menta

Fondere il cioccolato a bagnomaria. Aggiungere la panna liquida e il burro e amalgamare tutti gli ingredienti. Aggiungere quindi i tuorli d'uovo e, da ultimo 5 albumi montati a neve con 30 g di zucchero. Mescolare delicatamente. Per preparare il biscotto, montare a neve 3 albumi d'uovo e mescolarli con 70 g di zucchero fino ad ottenere una crema omogenea. Incorporare 3 tuorli e mescolare bene. Infine, aggiungere la farina avendo cura di mescolare delicatamente. Su un foglio di carta da forno stendere l'impasto così da ottenere una sfoglia rettangolare e infornare a 180 °C per 10 minuti.
Aiutandosi con una tasca da pasticciere versare la mousse sopra la cialda e servire. Decorare con un rametto di menta.

Sueño Na Xamena

Architect: Alvar Lipszyc I Chef: Oscar Bueno Nilsson

Hotel Na Xamena, urbanización Na Xamena I 07815 Ibiza
Phone: +34 971 334 500
www.hotelhacienda-ibiza.com
Opening hours: Mon–Sun 8 pm to 11 pm
Average price: € 50
Cuisine: Innovative Mediterranean cuisine
Special features: The chef uses varying gastronomic techniques, blending textures
and aromas from the sea and mountains of Ibiza

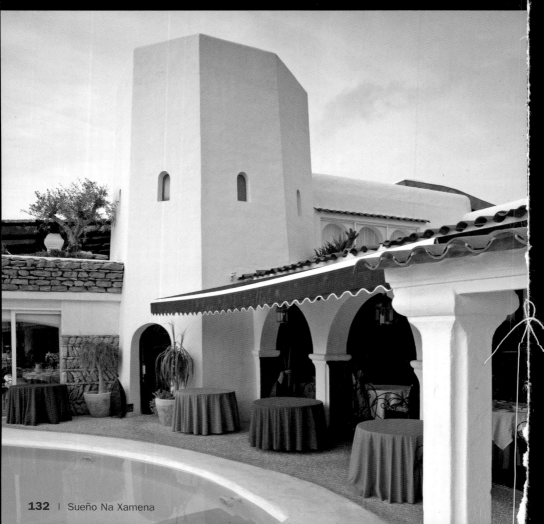

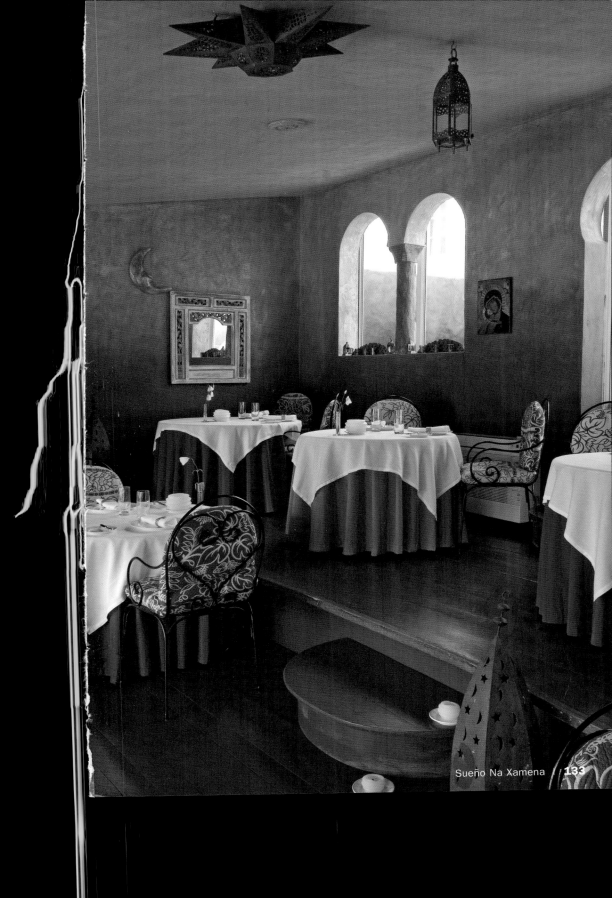

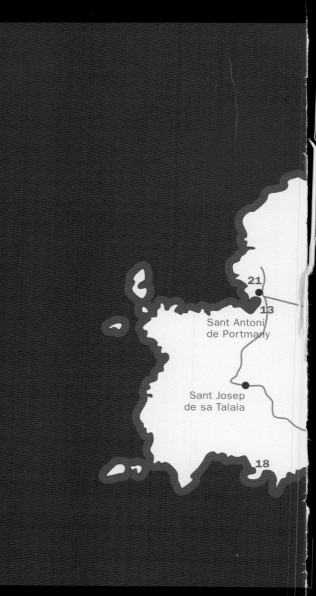

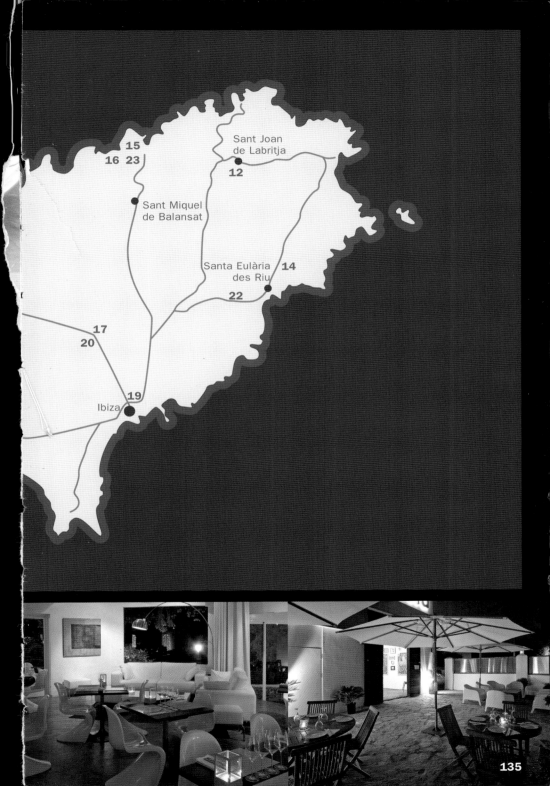

Sant Joan
de Labritja

15

16 23

12

Sant Miquel
de Balansat

Santa Eulària
des Riu 14

22

17

20

19

Ibiza

Cool Restaurants

Size: 14 x 21.5 cm / 5 $\frac{1}{2}$ x 8 $\frac{1}{2}$ in.
136 pp, Flexicover
c. 130 color photographs
Text in English, German, French,
Spanish, Italian or (*) Dutch

Other titles in the same series:

Amsterdam
ISBN 3-8238-4588-8

Barcelona
ISBN 3-8238-4586-1

Berlin
ISBN 3-8238-4585-3

Brussels (*)
ISBN 3-8327-9065-9

Cape Town
ISBN 3-8327-9103-5

Chicago
ISBN 3-8327-9018-7

Cologne
ISBN 3-8327-9117-5

Copenhagen
ISBN 3-8327-9146-9

Côte d'Azur
ISBN 3-8327-9040-3

Dubai
ISBN 3-8327-9149-3

Frankfurt
ISBN 3-8327-9118-3

Hamburg
ISBN 3-8238-4599-3

Hong Kong
ISBN 3-8327-9111-6

Istanbul
ISBN 3-8327-9115-9

Las Vegas
ISBN 3-8327-9116-7

London 2nd edition
ISBN 3-8327-9131-0

Los Angeles
ISBN 3-8238-4589-6

Madrid
ISBN 3-8327-9029-2

Miami
ISBN 3-8327-9066-7

Milan
ISBN 3-8238-4587-X

Moscow
ISBN 3-8327-9147-7

Munich
ISBN 3-8327-9019-5

New York 2nd edition
ISBN 3-8327-9130-2

Paris 2nd edition
ISBN 3-8327-9129-9

Prague
ISBN 3-8327-9068-3

Rome
ISBN 3-8327-9028-4

San Francisco
ISBN 3-8327-9067-5

Shanghai
ISBN 3-8327-9050-0

Sydney
ISBN 3-8327-9027-6

Tokyo
ISBN 3-8238-4590-X

Toscana
ISBN 3-8327-9102-7

Vienna
ISBN 3-8327-9020-9

Zurich
ISBN 3-8327-9069-1

teNeues